The Fun of the Fifties

ROBERT OPIE

ADS, FADS AND FASHION

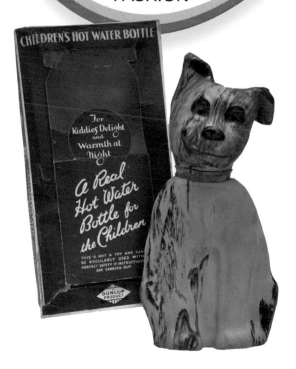

CHILDREN'S HOT WATER BOTTLE

For Kiddies Delight and Warmth at Night

A Real Hot Water Bottle for the Children

THIS IS NOT A TOY AND CAN BE REGULARLY USED WITH PERFECT SAFETY IF INSTRUCTIONS ARE CARRIED OUT.

DUNLOP PRODUCT

ATTRACTIVE

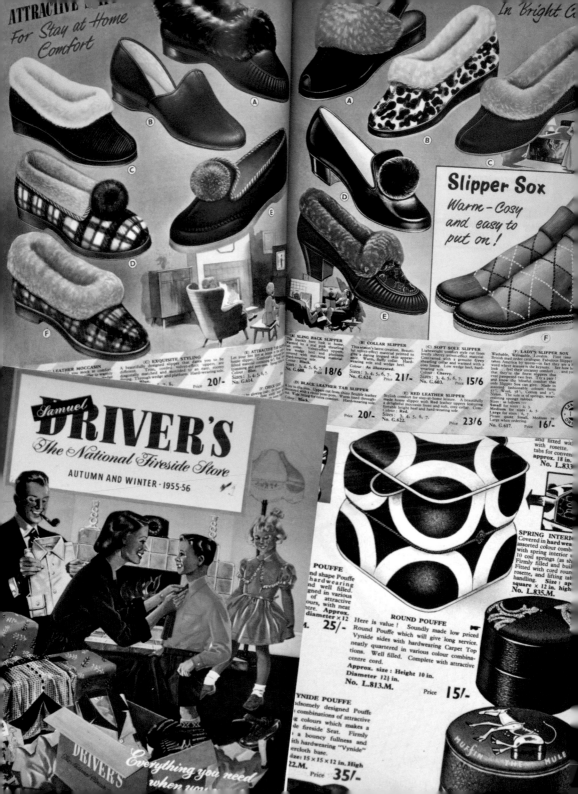

Slipper Sox
Warm – Cosy and easy to put on!

(A) SLING BACK SLIPPER
The franklin has look at home, backed by a real pink shearling on suede-effect uppers. Contrasted with a wedge heel and platform covered with matching material.
Colour : Black.
Sizes : 3, 4, 5, 6, 7.
No. G.608. Price **18/6**

(B) COLLAR SLIPPER
This season's latest creation. Beautiful velvet-effect material printed to give a daring leopard skin appearance. Warm, fluffy collar. Hard-wearing sole and wedge heel.
Colour : As illustrated.
Sizes : 3, 4, 5, 6, 7.
No. G.624. Price **21/-**

(C) SOFT SOLE SLIPPER
Lightweight comfort style cut from lovely cherry velvet-effect material. Contrasted with a genuine Grey shearling collar and warmed with a cosy lining. Low wedge heel, hard-wearing sole.
Colour : Cherry.
Sizes : 3, 4, 5, 6, 7.
No. G.603. Price **15/6**

(D) BLACK LEATHER TAB SLIPPER
Slip to slip into. Uppers cut from flexible leather decorated with a sweet pom-pom. Warm lined throughout. Wide store for extra comfort. Hard-wearing sole.
Colour : Black.
Price **20/-**

(E) RED LEATHER SLIPPER
Stylish comfort for stay-at-home leisure. A beautifully made home slipper with Red leather uppers featuring a delightful moccasin front and soft, cosy collar. Comfortable bright heel and hard-wearing sole.
Colour : Red.
Sizes : 3, 4, 5, 6, 7.
No. G.622. Price **23/6**

(F) LADY'S SLIPPER SOX
Washable, Wringable, Lovable. Cool too! British mail order catalogue. Fabulous Slippers taken America by storm — in fact they are a word where leisure is the keynote. See how you look ... feel their uncanny comfort ... and you that they're the finest slippers that you ever pampered two feet. Try a pair and know the blissful comfort that our Slipper Sox can give. Made in assorted fashionable colours from W, Wool, 18%, Cotton and 2% Nylon. The sole is of springy, wearresisting sponge rubber.
Sizes as follows :
Small for sizes 3, 4, 5
Medium for sizes 4½, 5
Large for sizes 6, 7
Please quote Small, Medium or Large when ordering.
No. G.617. Price **16/-**

(C) EXQUISITE STYLING
A beautifully designed slipper that dares you to be different. Trim, corded, velvet-effect uppers, additionally matched with moccasin front. Warm, roomy lining. Through wedge and platform. Hard-wearing sole.
Colour : Black.
Sizes : 3, 4, 5, 6, 7.
No. G.608. Price **20/-**

LEATHER MOCCASIN

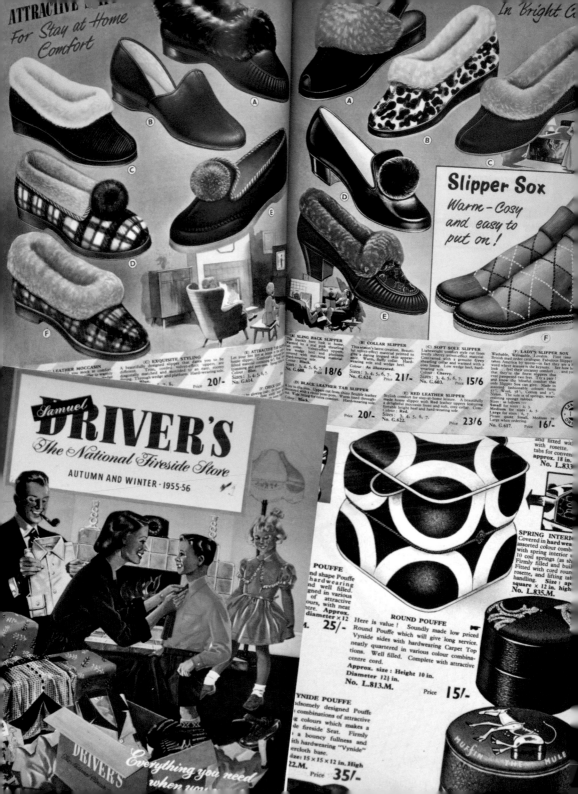

POUFFE
...and shape Pouffe ...hardwearing ...filled. ...ned in various ...of attractive ...ours, with neat ...tre. **Approx.** ...diameter × 12
...M. **25/-**

ROUND POUFFE
Here is value ! Soundly made low priced Round Pouffe which will give long service. Vynide sides with hardwearing Carpet Top neatly quartered in various colour combinations. Well filled. Complete with attractive centre cord.
Approx. size : Height 10 in. Diameter 12½ in.
No. L.813.M. Price **15/-**

VYNIDE POUFFE
...ndsomely designed Pouffe ...combinations of attractive ...g colours which makes a ...fireside Seat. Firmly ...a bouncy fullness and ...th hardwearing "Vynide" ...ercloth base.
...Size : 15 × 15 × 12 in. High
...M. Price **35/-**

...and fitted wit... with rosette... tabs for conven... approx. 18 in. No. L.833...

SPRING INTERIC...
Covered in hard wea... assorted colour comb... with spring interior w... 10 coil springs (as sh... Firmly filled and buil... Fitted with cord roun... rosette, and lifting tab... handling. Size : ap... square × 12 in. high... No. L.835.M.

First published in Great Britain in 2016 by
Michael O'Mara Books Limited
9 Lion Yard
Tremadoc Road
London SW4 7NQ

A CIP catalogue record for this book is available from
the British Library.

Every reasonable effort has been made to
acknowledge all copyright holders. Any errors or
omissions that may have occurred are inadvertent,
and anyone with any copyright queries is invited to
write to the publisher, so that a full acknowledgement
may be included in subsequent editions of this work.

Papers used by Michael O'Mara Books Limited are
natural, recyclable products made from wood grown
in sustainable forests. The manufacturing processes
conform to the environmental regulations of the
country of origin.

ISBN: 978-1-78243-527-3 in hardback print format
ISBN: 978-1-78243-644-7 in e-book format

1 2 3 4 5 6 7 8 9 10

www.mombooks.com

Cover design by Ana Bjezancevic
Designed and typeset by Design 23

Printed and bound in Malaysia

Contents

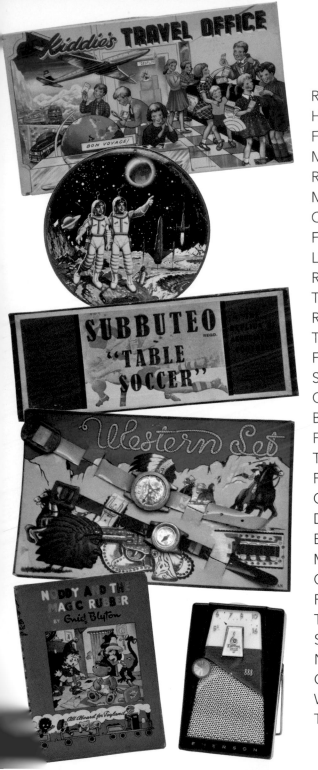

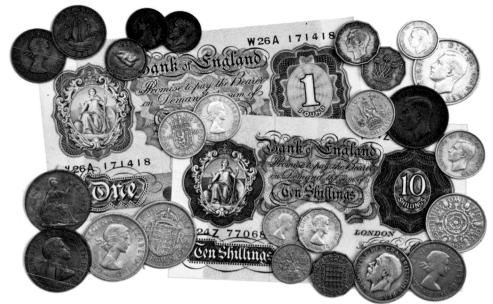

A Penny For Your Thoughts

Back in the day, Britain's currency had a personality all of its own – an eclectic range of coins much loved by the nation, though visitors from overseas were often baffled by certain aspects of an eccentric system. One pound comprised 240 pennies, a shilling (commonly known as a 'bob') equalled twelve pennies, and there were twenty shillings in a pound. The ten shilling note was the one of lowest value (the ten bob note); a little larger in size was the green £1 note.

The penny was the key to the system, with Britannia proudly seated on its reverse. A halfpenny (or ha'penny) had a ship on its reverse, while the little-used quarter of a penny was called a farthing, with Britain's smallest bird, the wren. (Farthings ceased to be legal tender at the end of 1960.) The threepenny bit was a brassy gold colour and had twelve sides, while the sixpence (or 'tanner') was the smallest of the silvery coins. Next up from the shilling was the larger two-shilling piece (also known as a florin) and then the impressive half crown (or 'two-and-six') and, as a child, you felt rich with 2/6d.

The Queen's head did not appear on the pound or the 10/- note until the beginning of the 1960s, but from 1953 all coins bore her head, replacing that of her late father, George VI. Of course, the sovereign's head from previous reigns continued in circulation, so pockets and purses maintained a link with the country's history back to Victorian times. During the 1950s, the *Radio Times* cost 3d, as did a Wagon Wheel, the *Eagle* cost 4½d and a 2oz bar of chocolate 6d – and the tooth fairy gave you sixpence.

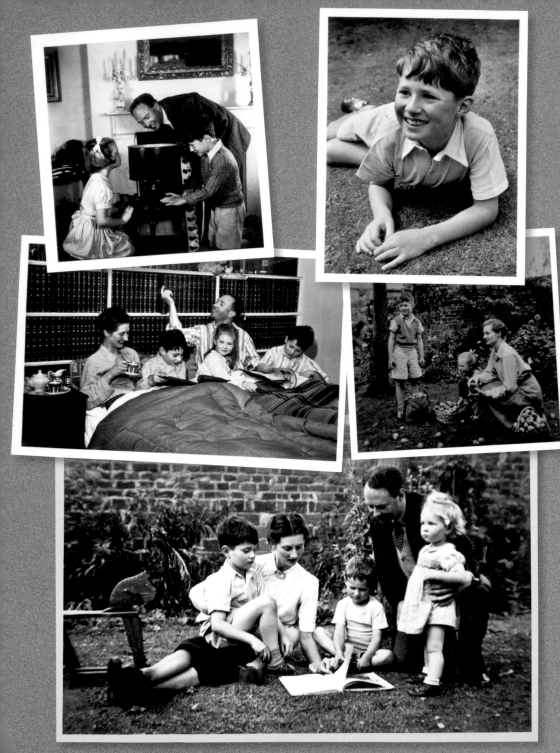

James, Robert and Letitia with parents, Iona and Peter Opie.

My Fifties

Roller skating, football, Dinky Toys in the sand, temptation in the toy shop, flying kites, horse riding, apple pie (made by me), queen of puddings (made by my mother), the ditties of Edward Lear read

by my father, spinning zoetrope, admiration for the cartoons of H. M. Bateman, seaside holidays looking for cowrie shells, making xmas decorations from crepe paper, Christmas stockings and presents such as the *Rupert* annual, reading comics – *Dandy*, *Beano*, *Eagle* – the smell of the paraffin flame from the Aladdin stove, warming Plasticine to make it malleable, magic painting books, cutting out cardboard vehicles and masks from cereal boxes, playing Dover Patrol with my father, Monopoly with my brother, constructing cranes from Meccano, gardening with my sister on our

respective plots, bicycling expeditions with my parents, special Mum-made birthday cakes.

My earliest memories include a visit to the Festival of Britain exhibition of children's books at the Victoria & Albert Museum, for which my parents had lent material; wondering why adults were wearing black armbands when George VI died; watching the Coronation on my grandmother's television. We didn't have a television set, but often listened to radio programmes like *The Navy Lark*, *Round the Horne*, *The Goon Show* and *Hancock's Half Hour*. Another memory was being given an Archie Andrews doll when its creator, Peter Brough, came to visit my father. Also, saving up with my sister to buy a record for Dad's birthday – we knew he wouldn't like it, but we did: 'Rock Island Line' by Lonnie Donegan.

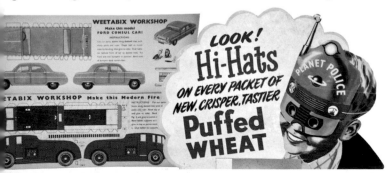

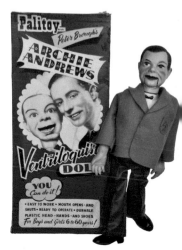

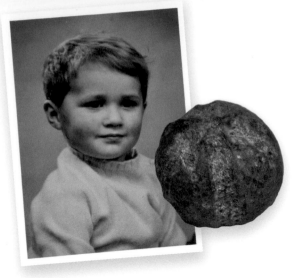

was a fossilized sea urchin. Collecting stones became a hobby, as did coins. But it was stamps (and later postal stationery) that were to inspire my visual appetite; postage stamps were miniature marvels of design, had geographical interest and gave a historical perspective. Another subject I took seriously was Lesney Matchbox die-cast toys – pocket-money priced vehicles, with each new model eagerly anticipated every month. My father encouraged me to write the date and price paid on the box – a lesson in curatorship.

Many children instinctively save and collect things. As an inquisitive three-year-old, I wondered what this round stone was that I found in the garden path – my mother told me it

Our home was in Alton, Hampshire; it overflowed with my parents' collection of children's books (now housed at the Bodleian Library, Oxford), which filled the shelves in

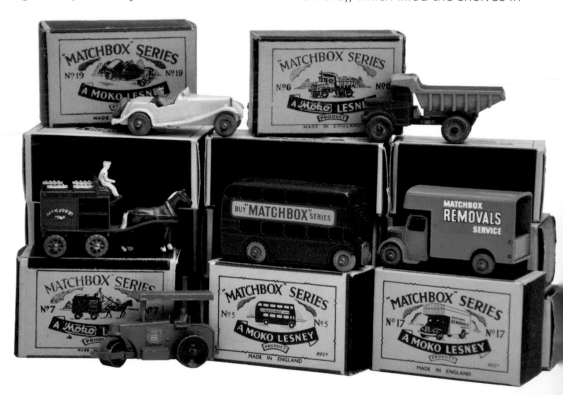

many rooms and corridors. In the study, a selection of early playthings were on display ... didn't every home have its own small museum? It was here that my parents, Iona and Peter Opie, studiously researched their formidable books: *The Oxford Dictionary of Nursery Rhymes*, published in 1951, *The Oxford Nursery Rhyme Book* (1955) and *The Lore and Language of Schoolchildren* (1959). It was in this rich mix of intellectual nutriment that I grew up.

An early achievement for me, at the age of six, was the compilation of my Coronation scrap book, which contained not only the chronological build-up to the big event in pictures cut from newspapers and magazines, but also a selection of commemorative milk bottle tops, stamps, advertisements and bread wrappers. This endeavour – of picture and paste, layout and love – won me first prize at school. It was a precursor of things to follow – a series of scrap books (with over a thousand images in each era), the founding of the Museum of Brands (museumofbrands. com), a two-hour DVD documentary entitled *In Search of our Throwaway History*, (throwawayhistory.com)and a comprehensive archive of consumer history that extends to over 500,000 items, from which a selection has been chosen to illustrate this book.

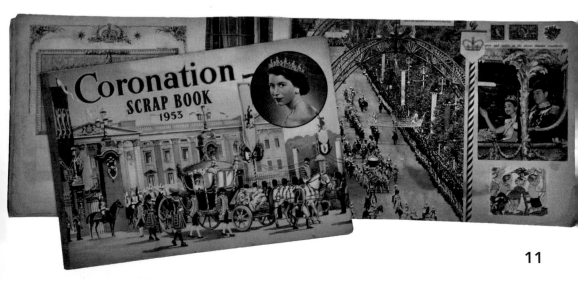

Austerity to Aspiration

On page 152 of the 1950 Ideal Home Exhibition catalogue, an announcement declared 'a triumphant vindication of British superiority in design and manufacture unsurpassed in its uses and efficiency'. It was the versatile new food mixer, the

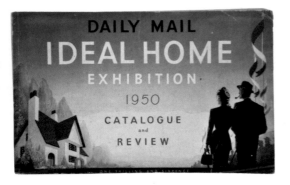

Kenwood Chef – every housewife's dream kitchen gadget. Britain was in recovery mode, and in 1951 the vibrancy of the Festival of Britain was celebrated throughout the nation, even though there were those who thought it an unnecessary expense.

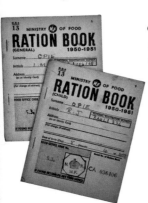

Rationing was fast disappearing: petrol, clothes, paper, soap, tea, eggs and then, in 1953, sweets, just before the Queen's coronation, which now set the tone for the 1950s with its rich pageantry of

colour – austerity was banished.

It was time for homes to embrace colour – cookers, refrigerators,

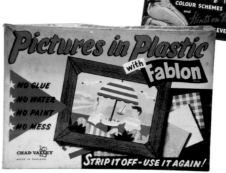

carpet sweepers, bathroom suites, all came in a range of modern colours. A touch of DIY with a liberal coating of Formica or Fablon gave kitchens new life. Television, of course, remained in black and white throughout the 1950s.

Change was coming to the high street as the concept of the self-service store gradually took hold, and a wary public experienced the sensation of taking the product off the shelf themselves and placing it in a wire basket. Brand owners now realized that the supermarket revolution was going to alter the shopping dynamic. Packs needed to shout from the shelf to ensure

they were visible – graphics were sharpened up and colours brightened. New products were also arriving: frozen foods, tea bags, instant coffee, sugar-coated breakfast cereals, detergent washing powders and, for many, the luxury of soft toilet tissue from Andrex. With the ability to make flexible plastic containers came the excitement of squeezing out washing-up liquid or the novelty of squirting lemon juice.

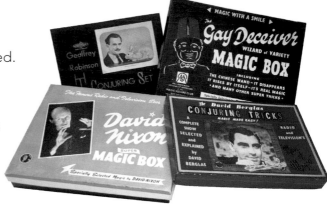

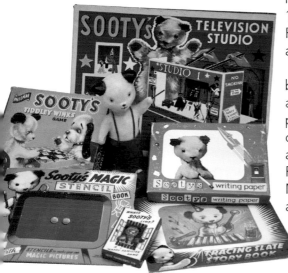

In 1946, the fledgling television service was switched on again, and through the 1950s children could enjoy the fun of Muffin the Mule, Hank, Mr Turnip, Sooty and many other favourites. Toy cupboards bulged with character merchandise. Television was to transform British culture, gradually eroding the habit of going to the cinema or the pub. TV made people into personalities, such

as the cook Philip Harben (Harbenware non-stick saucepans were launched in 1956), the home economist Marguerite Patten, gardening expert Fred Streeter and 'Mr DIY' Barry Bucknell.

The magician David Berglas had been hugely successful on radio, and then on television his magic proved equally popular as the closeness of the camera made it more amazing. Fellow magicians Geoffrey Robinson (on *Whirligig*) and David Nixon also found fame, as did the alternative comedic magic of Tommy Cooper. Another area to benefit from the 'goggle box' was natural history; David Attenborough's *Zoo Quest* was a portent of things to come.

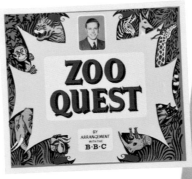

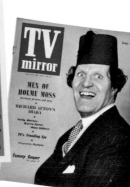

too good to hurry mints.' TV enriched everyone's lives, whether it was *Crackerjack* (from 1955), *Blue Peter* (1958) or the abundance of cowboy adventures that in 1954 inspired the name for 'the richer, sweeter, bigger, chocolate thrill' Wagon Wheels, measuring 3¼ inches across.

When, in 1955, the commercial channel ITV began (Gibbs SR toothpaste was the first commercial to be shown), it wasn't long before it was outperforming the BBC, partly because ITV could offer big cash prizes on its quiz programmes – perhaps this encouraged Premium Bonds, launched in 1957. It wasn't only catchphrases like Bruce Forsyth's 'I'm in charge' that were now in people's minds, but also the persistent repetition of advertising jingles: 'Murray Mints, Murray Mints,

It wasn't just cowboys, there were many other influences coming from America – cars with chrome bumpers and Hollywood celebrities such as Marilyn Monroe. The recently defined teenager generation wanted to be different, wearing blue jeans, playing Elvis Presley or Buddy Holly records, gyrating to the beat of rock 'n' roll with Bill Haley, so different from the hugely popular ballroom dancing promoted by Victor Silvester. The ultimate rebellious statement came from the Teddy Boys, with their hair Brylcreemed into a quiff, drainpipe trousers and 'brothel creeper' shoes.

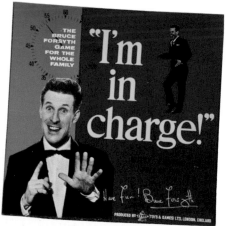

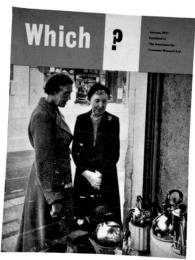

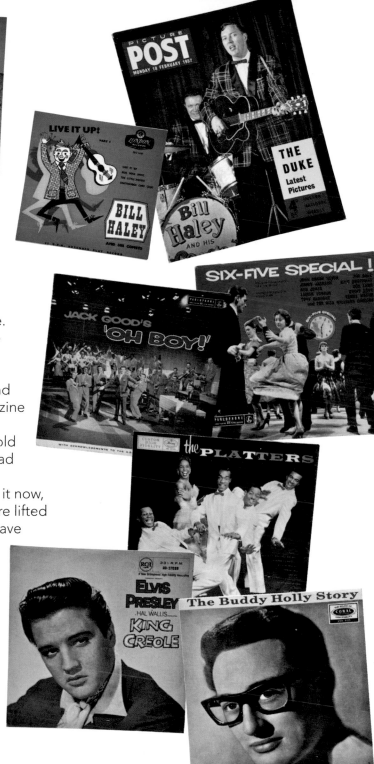

There was more fun to be had by more people in the 1950s than at any time before. Little wonder though that the consumer boom needed the Consumers' Association to independently test, review and make comparisons in a magazine called *Which?*, launched in 1957, the same year that Harold Macmillan said that Britain 'had never had it so good'.

Even if you couldn't afford it now, hire purchase (restrictions were lifted in 1954) enabled families to have what they wanted sooner – the latest radio or TV set, a record player or a refrigerator, spin dryer or dishwasher, a motor car or scooter. For those who didn't sign up to the 'never never', aspirations for a better life could be seen just round the corner – even if it was only a Kenwood mixer.

Festival of Britain, 1951

'The visitor will see Britain full of hope and brightness', said the leaflets. The Festival of Britain, held in 1951, was inspired by the centenary year of the Great Exhibition of 1851 – the building in London's Hyde Park became known as the Crystal Palace.

Arts festivals and exhibitions were opened all over Britain – an explosion of festivity, colour, design and exuberance that temporarily banished the grey feeling of austerity and rationing. Built on the South Bank of the Thames, the focal point included the Dome of Discovery, the Skylon and Battersea's Pleasure Gardens, where Emett's Railway ran – 'the craziest railway in the world'. The Festival motif, designed by Abram Games, adorned a host of souvenirs.

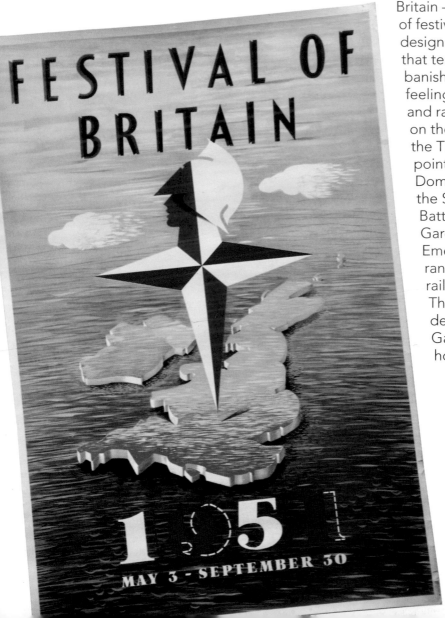

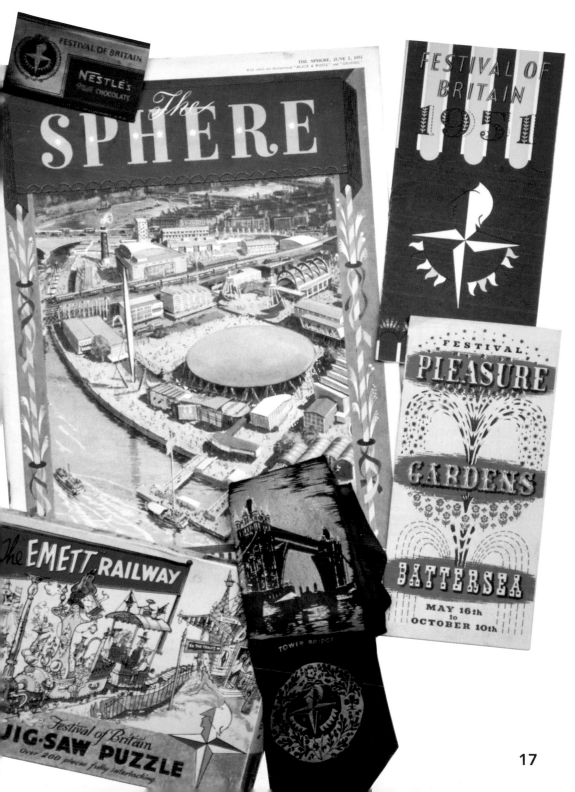

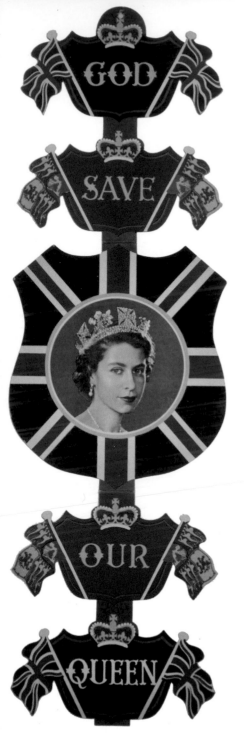

Coronation, 1953

'God Save our Queen' shouted the banners, 'Long Live the Queen' proclaimed the souvenir doll's toy brush set. All over the United Kingdom shops were overflowing with commemorative wrapped bread and bars of chocolate, procession panoramas and transfer story books, paper dolls and biscuit or sweet tins. Perhaps the most unlikely souvenir was a flint lighter to ignite your gas cooker. On 2 June 1953, two million people lined the processional route, while twenty million more were huddled around their own or a neighbour's television set. It was the first time that the public had watched the actual crowning ceremony and the ritual anointment with the holy oil.

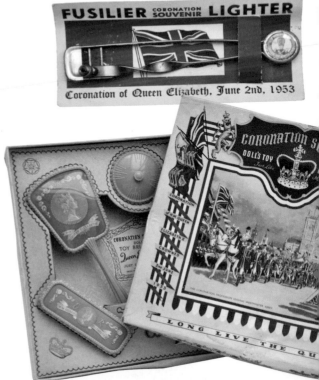

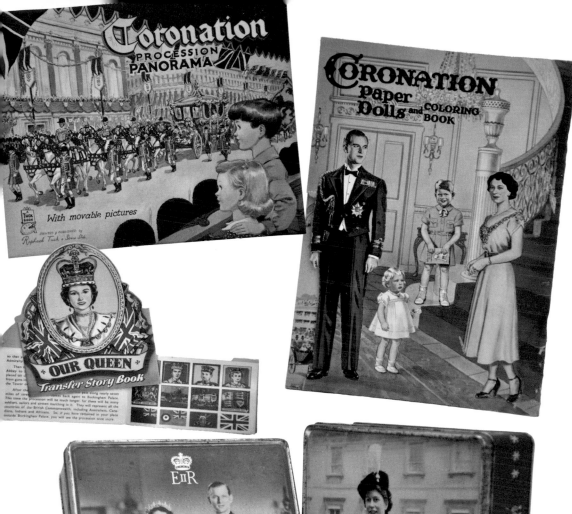

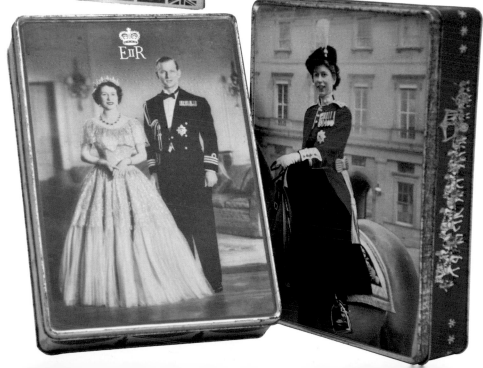

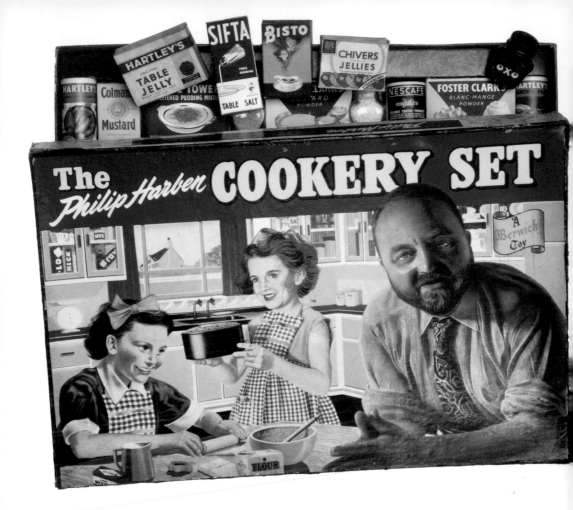

Cooking

'The size of it, the beauty of it, you've never seen the like of it. How wise you were to wait for Britain's most carefully planned cooker. Britain's most advanced cooker', claimed the new Tricity Viscount, along with its streamlined cleaning. Housewives were continually enticed by this promotional patter that proffered new features, such as automatic time-controlled cooking, 'a boon to the woman who has to be away from home all day. When she comes home the meal is already freshly cooked, piping hot, ready to serve.' Or maybe it was Cannon's exclusive foldaway eye-level grill. For mother's little helpers, there was plenty to keep them busy, including a cooker set full of miniature products, and endorsed by television's first celebrity chef, Philip Harben.

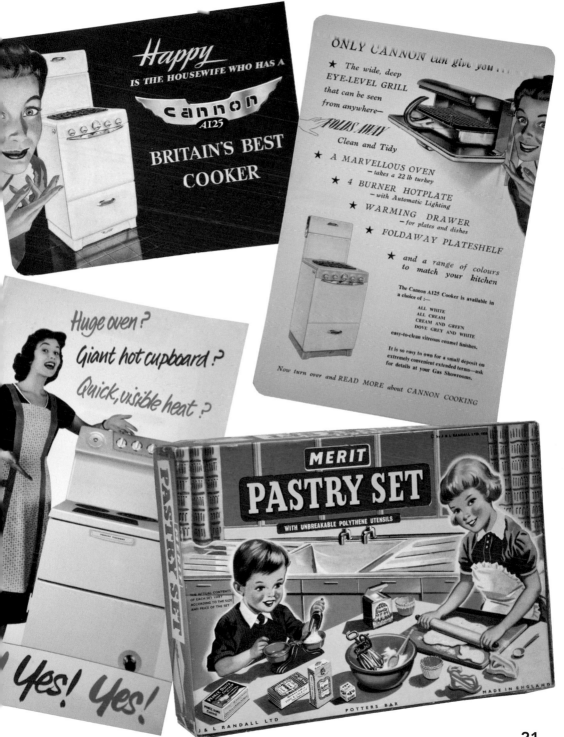

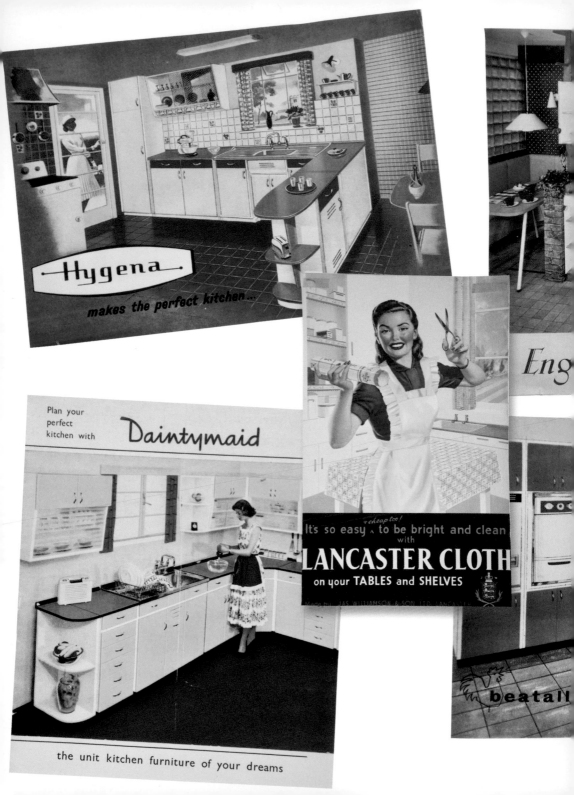

Hygena

makes the perfect kitchen...

Plan your perfect kitchen with **Daintymaid**

the unit kitchen furniture of your dreams

cheap too!

It's so easy to be bright and clean with

LANCASTER CLOTH

on your **TABLES** and **SHELVES**

Made by JAS. WILLIAMSON & SON LTD. LANCASTER

beatall

Eng

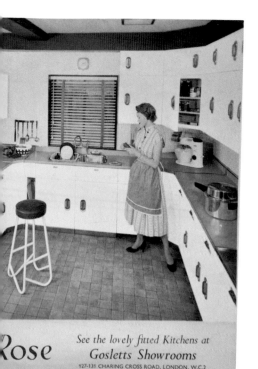

Rose See the lovely fitted Kitchens at
Gosletts Showrooms
127-131 CHARING CROSS ROAD, LONDON, W.C.2

Kitchens

'Every woman has a perfect kitchen in her heart ... not only because she would like to be proud of modern, gleaming fittings, but perhaps even more so because she deserves to be freed from unnecessary drudgery, cleaning and inconvenience. It would be fun, at least to plan your ideal kitchen, wouldn't it!' So went the blurb on the 1953 leaflet for Paul kitchen equipment. It was during this decade that fitted kitchens took off, replacing the multipurpose maid-saver unit and an assortment of uncoordinated components. The housewife's choice for 'the kitchen furniture of your dreams' was between the brand names – English Rose, Hygena, Daintymaid or Beatall.

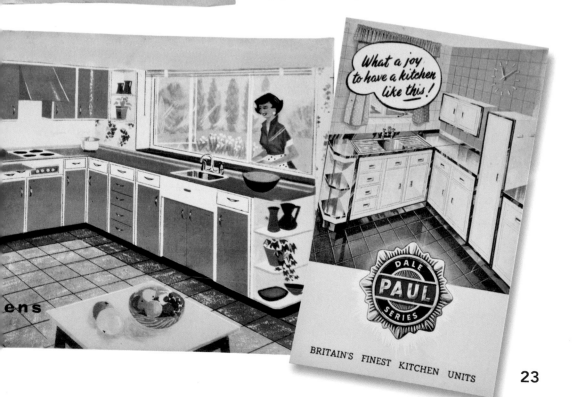

What a joy to have a kitchen like *this*!

DALE PAUL SERIES

BRITAIN'S FINEST KITCHEN UNITS

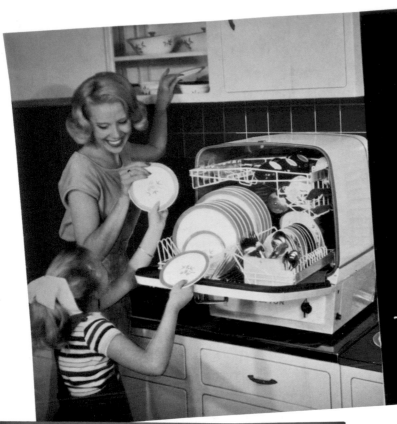

Washing-up has gone for good!

COLSTON is here for *every* home!

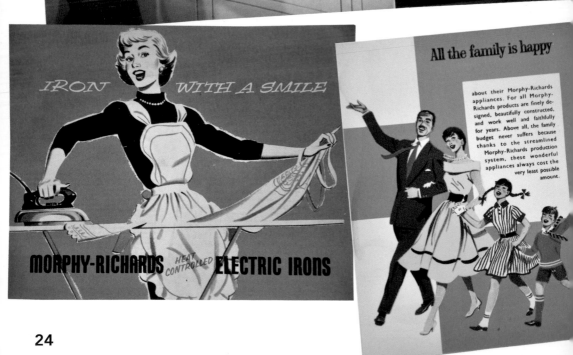

IRON WITH A SMILE

MORPHY-RICHARDS HEAT CONTROLLED ELECTRIC IRONS

All the family is happy

about their Morphy-Richards appliances. For all Morphy-Richards products are finely designed, beautifully constructed, and work well and faithfully for years. Above all, the family budget never suffers because thanks to the streamlined Morphy-Richards production system, these wonderful appliances always cost the very least possible amount.

24

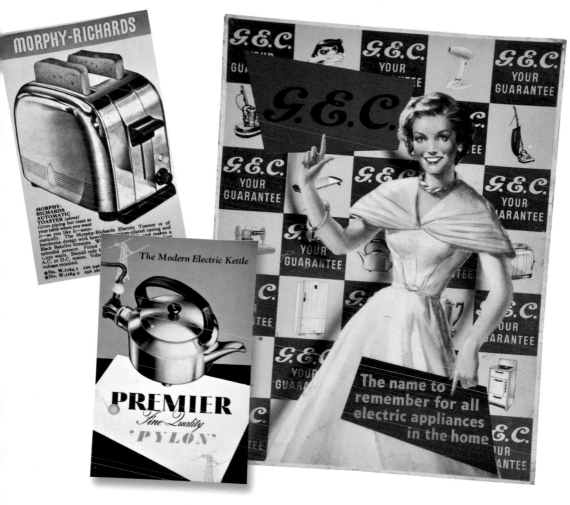

Electrical Appliances

The modern way of life now revolved around electricity, and electrical goods were filling family homes. Dad could now have an electric shaver and a power drill for DIY. Mum could enjoy the convenience of an electric hair dryer, sewing machine, electric iron, vacuum cleaner and, in the kitchen, a food mixer, kettle and pop-up toaster. Perhaps the ultimate in luxury was a dishwasher – 'switch on the washing-up

and walk away. You can rejoin the family and forget it, the Colston even switches itself off.' Of course, electricity had been lighting a few well-off homes since late Victorian times, and the national grid had been in place since 1934, so electric fires and kettles had been part of domestic life for a while. Only now were they gradually becoming affordable to many. The question was which to buy first – a television set or a fridge?

Food Mixers

'It's the star turn in my kitchen,' says Miss Jean Kent, actress and TV star. 'I simply couldn't do without it.' The Magimix claimed it made 'exciting meals in a few seconds, and will cream soups, grate carrots and cheese, make breadcrumbs, mix batters, and chop or pulp raw vegetables and fruit so finely that every particle of peel may be used, and all health-giving vitamins are retained.'

In America, Sunbeam had made electric home appliances since 1910; the Mixmaster had arrived in 1930. In Britain, Ken Wood developed a mixer, which was launched in 1947, but it was his Kenwood Chef, which made its debut at the Ideal Home Exhibition of 1950, that suddenly stirred sales. Kenwood's Roto-blend included attachments that converted it into a liquidizer, shredder or high-speed slicer.

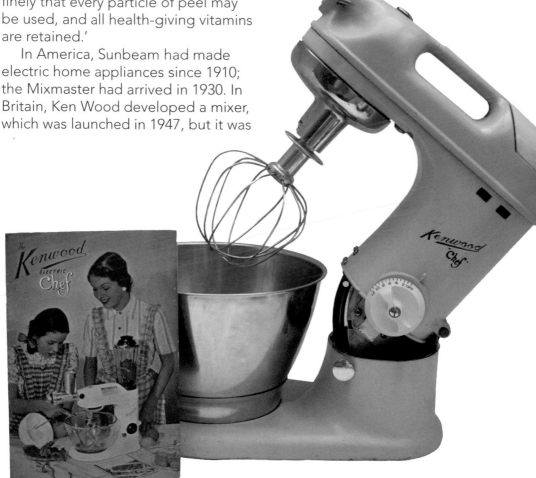

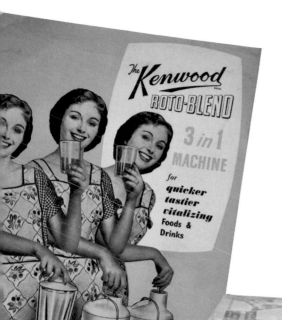

The **Kenwood**
ROTO-BLEND

3 in 1 MACHINE

for **quicker tastier vitalizing** Foods & Drinks

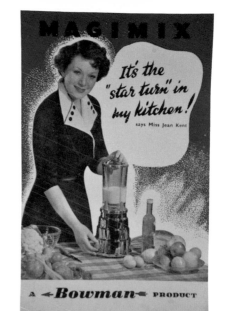

MAGIMIX

It's the "star turn" in my kitchen!

says Miss Jean Kent

A ►**Bowman**◄ PRODUCT

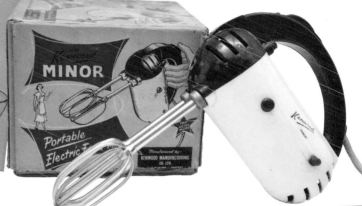

MINOR

Portable Electric *Manufactured by* KENWOOD MANUFACTURING CO. LTD.

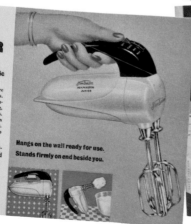

Sunbeam
MIXMASTER JUNIOR

in's only **3** speed electric hand mixer

advantages of power mixing are
e in this best of all hand mixers.
speeds set in an instant by the con-
thumb-tip control for all mixing.
, whipping, stirring and beating jobs.
aters are grooved for better aeration
achable without mess or bother.
onveniently beside stove or work-top
ays ready for instant use.

riced, time saving power-
for the small household

S · WHIPS · BEATS · STIRS
FOLDS and MIXES

tip control. Large Beaters
Easy beater ejection
AC/DC 220-240 v.

Hangs on the wall ready for use.
Stands firmly on end beside you.

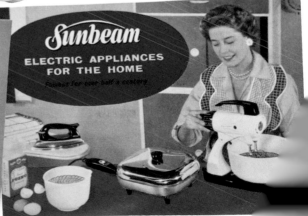

Sunbeam
ELECTRIC APPLIANCES FOR THE HOME
Famous for over half a century

Groceries

Long before the introduction of plastic carrier bags, housewives had used a shopping basket to bring back their groceries – paper bags were used for loose produce and some shops, like the butcher, would provide a strong paper carrier bag. Now, with the gradual movement to self-service stores (the larger ones were called supermarkets), the pre-packaged product came into its own.

Many brands had been around for a while: Bassett's Allsorts (1899), Daddies sauce (1904), Smith's potato crisps, Cadbury's drinking chocolate and Lyon's individual fruit pies all from the 1920s, and Roses chocolates from 1937. Two new arrivals were Maxwell House instant coffee, joining Nescafé (1939) to encourage the instant coffee market, and Nesquik in 1955 to the delight of children. Ambrosia rice pudding was available in the late 1930s, but disappeared from shops until after WWII, when it was relaunched.

Television commercials began in September 1955, a powerful way of promoting products in the comfort of your own home – but personal recommendation was still important. 'You must try it – it's delicious.'

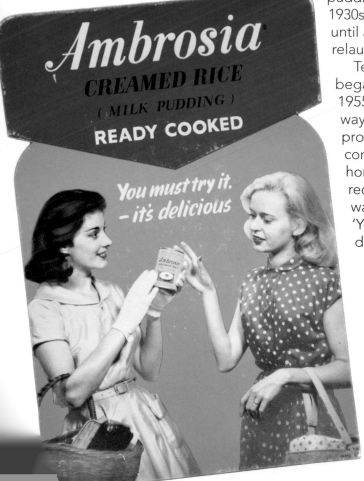

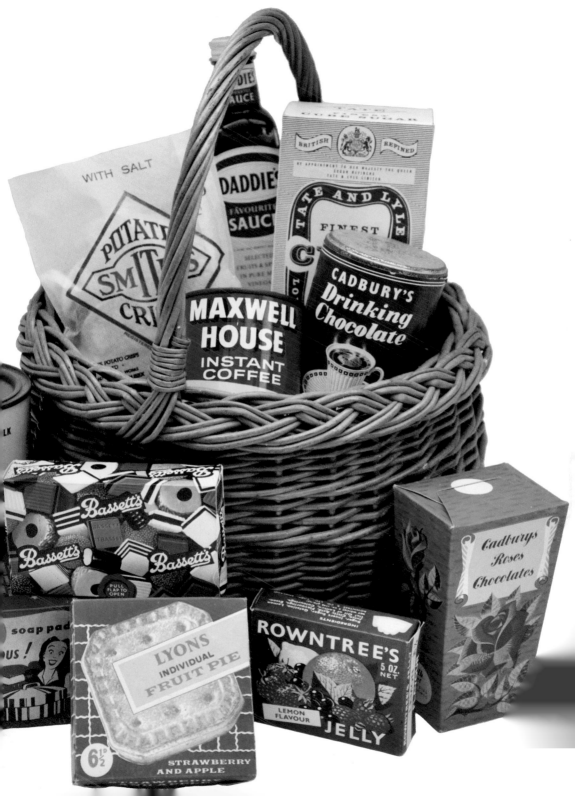

Breakfast Cereals

'They're GR-R-REAT!' said Tony the Tiger in 1955, a year after Kellogg's launched Frosted Flakes and kick-started sugar-coated breakfast cereals in Britain. At the same moment, Quaker produced Sugar Puffs promoted by a 'loveable little engine, Sugar Puff', his adventures were told on the back of the cereal box. Selling to children was the focus for cereal companies, and boxes were adorned with all manner of cut-out toys. Weetabix (launched in 1932) had a 'smashing cut-out model on every pack'.

The large size of Kellogg's Corn Flakes boxes (arrived in the UK in

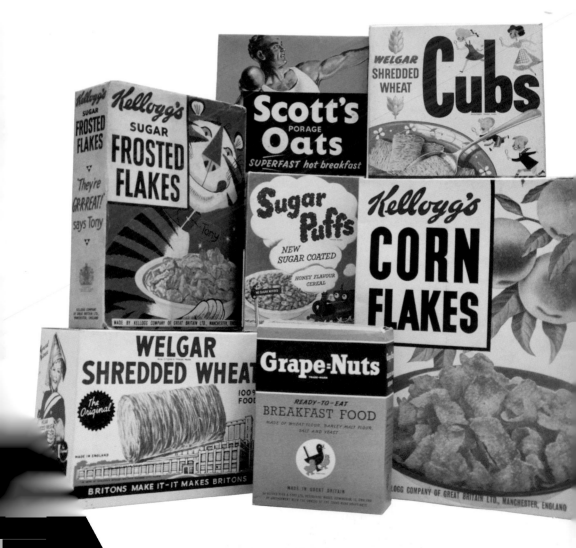

1922) and Quaker's Puffed Wheat packs (1920s) made them ideal for face masks or hats. Welgar Shredded Wheat (made in Britain since 1925) encouraged youngsters to save its cardboard models, 'Children! Start collecting this exciting and colourful Coronation procession!' and also, 'Hullo, boys and girls! Start collecting now this wonderful series of 21 panels.' Scott's Porage

Oats (1914) printed a menagerie of zoo animals on the back of its boxes.

In the second half of the 1950s, a plastic toy model began to be added into the pack, another reason to pester Mum for a particular brand. The most memorable toy was a miniature atomic submarine, which would rise and fall with the addition of baking powder. Welgar's Cubs was launched in 1958,

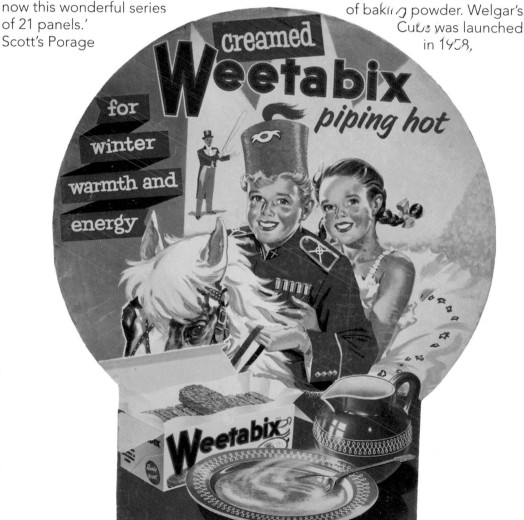

Frozen Foods

Even by the end of the 1950s, only around one in five households had a refrigerator, but it was becoming more of a necessity rather than a luxury. Smedley's had experimented in the late 1930s, but it was in 1950 that Birds Eye began to introduce a range of frozen fruit and vegetables, and in 1955 its fish fingers made a convenient appearance, 'just heat and serve'.

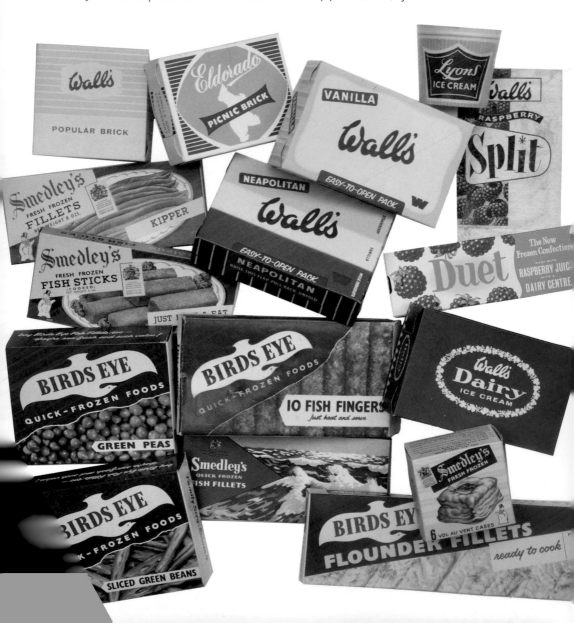

Smedley's followed with fish sticks, but soon also called them fish fingers, 'just heat and eat'.

If you could afford a fridge, it transformed domestic life. The milkman may have delivered daily, but on a warm day milk lasted longer in a fridge rather than a cooler, and so did the cornucopia of goodies as suggested by the GEC advertisement 'Here's beauty and reliability' – ice cream and lollies, meats and eggs, jelly and trifles. No longer did you need to rush back home from the grocer with your Wall's ice cream brick wrapped in layers of newspaper to eat immediately.

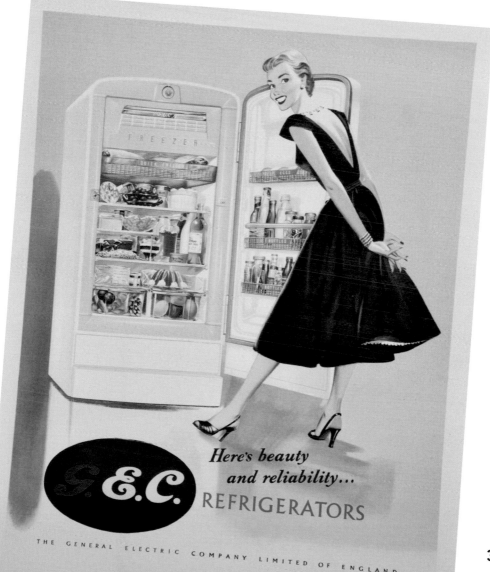

Here's beauty and reliability...

G.E.C.

REFRIGERATORS

THE GENERAL ELECTRIC COMPANY LIMITED OF ENGLAND

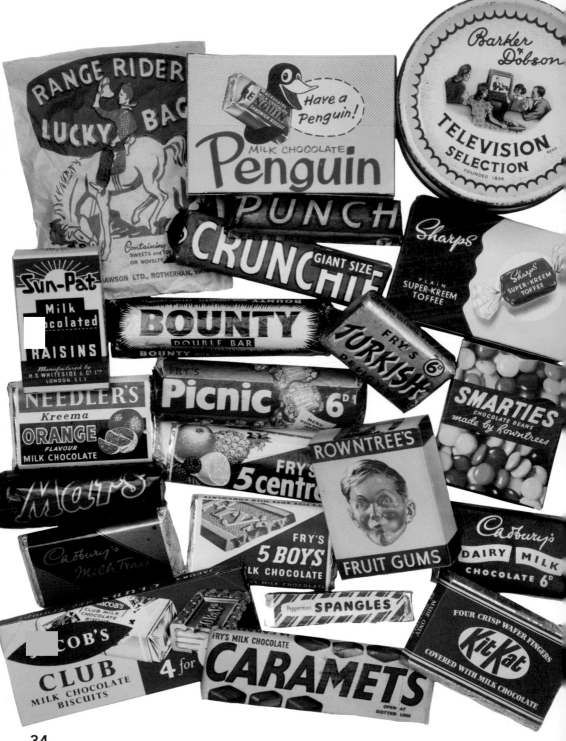

Sweets

Smiles beamed on every child's face (and on those of many adults) when the wartime sweet ration ended in February 1953, just before the Coronation. Many of Britain's favourites had been launched during the 1930s – Mars bars, Milky Way, KitKat, Smarties, Crunchie, Penguin. Some brands went back further, such as Fry's 5 Boys (1902) and Cadbury's Dairy Milk (1905). The coconut Bounty bar was a new arrival in the early 1950s; Picnic was the success at the end of the decade. Boiled sweets and toffee had been the sweet confection of the Victorian era as chocolate was then a luxury. By the 1950s, Spangles had arrived (1948) at 3d a pack and chocolate bars mostly cost 6d. The long-established firm of Barker & Dobson (1834) decided that television viewers needed their own selection in a hand-around tin.

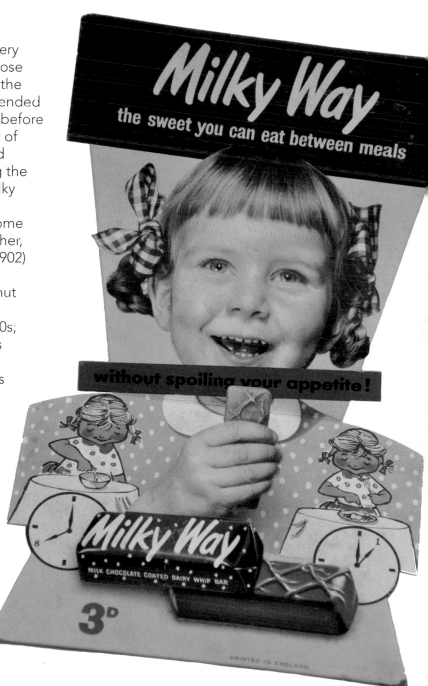

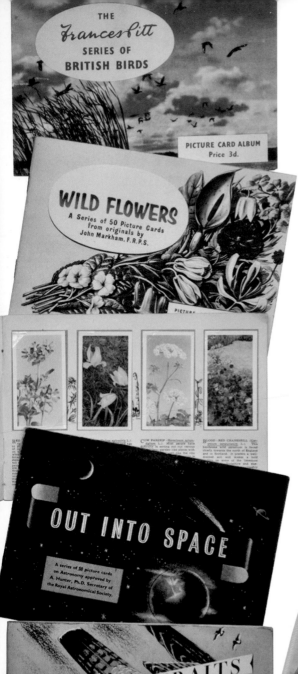

Tea

The rationing of tea ended in 1952, and two years later Brooke Bond launched its tea bags. Also in 1954, it added tea cards inside each pack. Cigarette cards had stopped with the onset of war in 1939; now the card collecting bonanza was back, and thousands of youngsters started swapping doubles with their chums to complete a set of 50 – British Birds, Wild Flowers and, in 1956, Out Into Space. Every issue had its own picture card album so you knew which cards were missing.

Other tea companies joined in the fun, like Priory in 1956 who cleverly combined the popularity of I-Spy books, when boys and girls looked out for everyday things. Brooke Bond ended tea cards in 1999.

The Goblin Teasmade had first seen service in 1936, to be revived after the war, bringing a little bit of luxury to many.

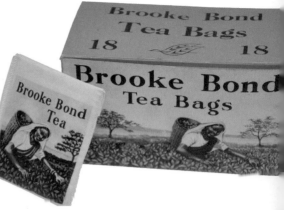

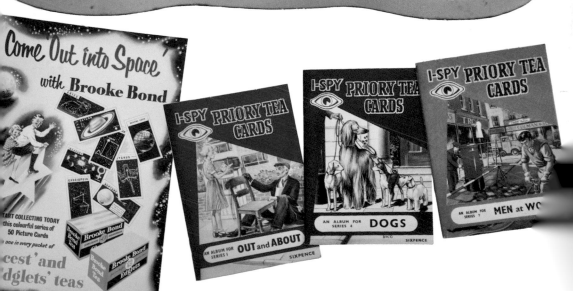

Drinks

'Normal service will be resumed as soon as possible' became a frequent refrain on television screens in the early 1950s. As most television was shown 'live', there were gaps between programmes to allow for changes between studios, as well as breakdowns in transmission. The 'interlude' became part of the watching ritual, and advertisers suggested their products were a refreshing drink for such occasions – the 'supreme tonic restorative' of Hall's wine or VP's rich ruby wine.

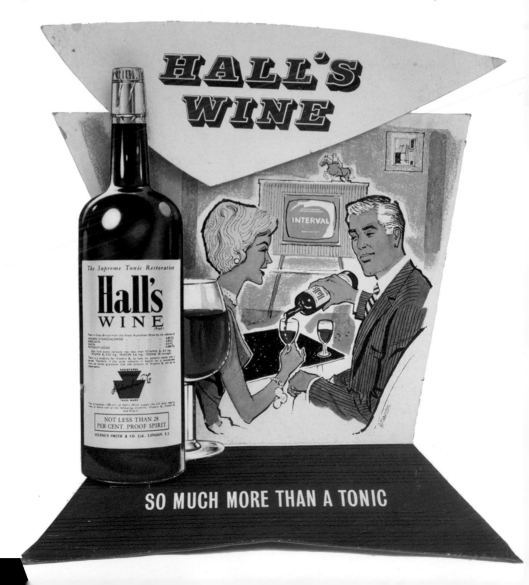

On all occasions

'CORONA'
SPARKLING & FRUIT SQUASHES

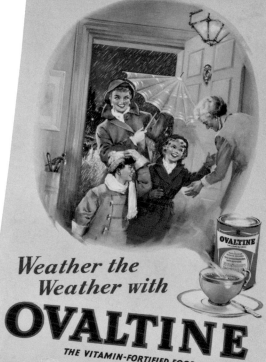

Weather the
Weather with

OVALTINE
THE VITAMIN-FORTIFIED FOOD BEVERAGE

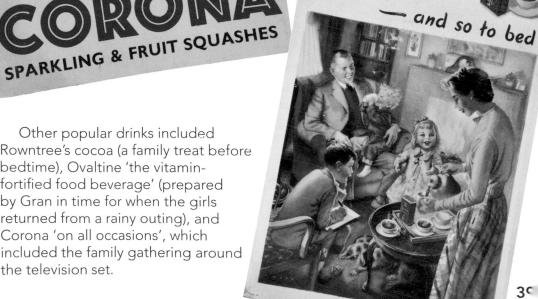

Rowntree's Cocoa

— and so to bed

Other popular drinks included Rowntree's cocoa (a family treat before bedtime), Ovaltine 'the vitamin-fortified food beverage' (prepared by Gran in time for when the girls returned from a rainy outing), and Corona 'on all occasions', which included the family gathering around the television set.

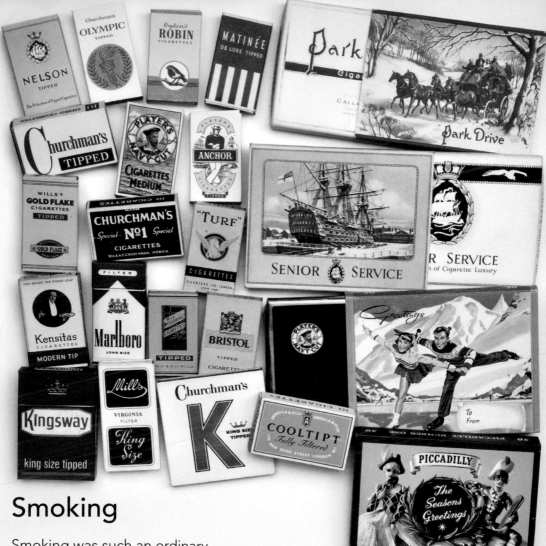

Smoking

Smoking was such an ordinary part of daily life, that giving your husband a pack of 50 cigarettes as a Christmas present was not unusual – indeed, tobacco manufacturers added value by gift wrapping each box with a festive sleeve. In 1950, 80 per cent of men smoked, but women were catching up, with 40 per cent indulging (although smoking more lightly). 'Get together with Bachelor tipped' was one message, and filter cigarettes were clearly the way forward, being seen as a healthier option. But old habits die hard, and by 1955 only 2 per cent of sales were for filter tipped. Another move in the 1950s was towards 'king size' (or long size) like Marlboro and Churchman's K.

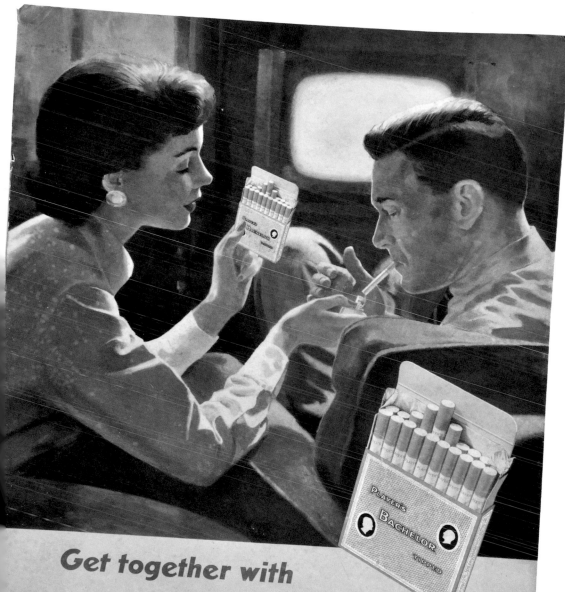

Get together with

BACHELOR TIPPED

They're good - very good!

Home Novelties

Instinctively, we love a novelty, and this was especially true after years of austerity. Weird and wacky, bizarre and batty, home novelties were conversation starters – and stoppers. Table clocks, for instance, were now kitted out with a musical theme. The French poodle became a familiar motif, appearing on every article imaginable – clothes, handbags, ashtrays – there were even plastic poodles as sweet containers, and woolly covers to hide a wine bottle.

Who could dream up a dice table lamp? Someone did. The home cocktail bar was a status symbol to show off to friends before dinner. An assortment of knick-knacks was an essential component of fun conversation and intrigue, such as highball cocktail mixers, all created out of coloured plastics with whistles attached. Another novelty was the Pancho guitar bottle opener – 'it's magnetic' – alongside the ladies' new drink, Babycham, launched in 1953.

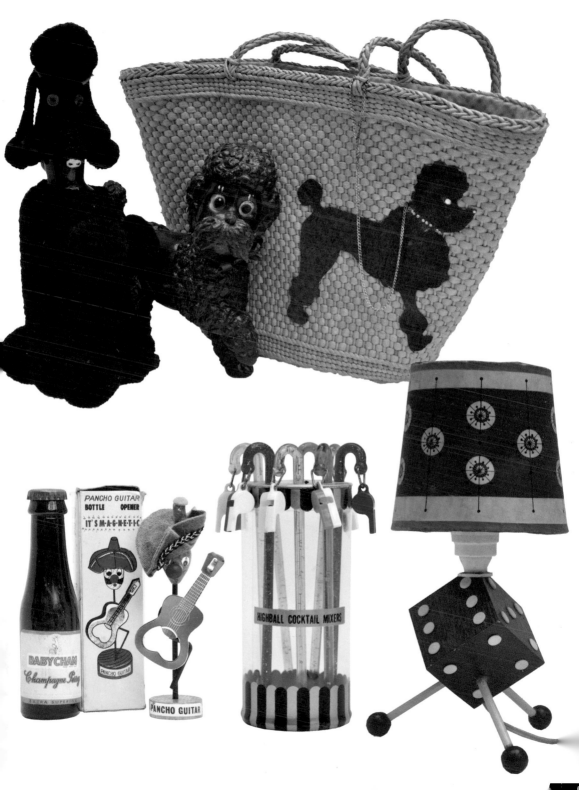

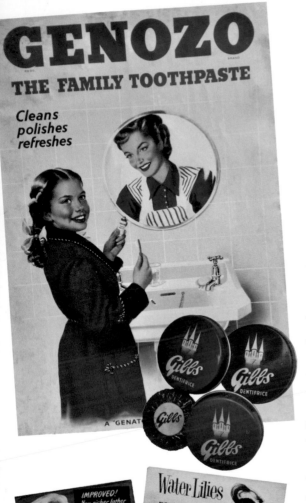

Toiletries

Before central heating was in most homes, everyone wanted a snug dressing gown, especially when cleaning your teeth – and Mum looks on with approval. Toothpaste now mostly came from a tube, tooth powder having been overtaken by 'ready made', except with the favourite for many, Gibbs dentifrice, which came in different coloured containers for each member of the family – it still needed a wet toothbrush to be wiped over the solid paste.

At the beginning of the 1950s, shampoo came mostly in powder form that needed to be mixed with hot water. A few ready-made shampoos, like Drene and Vosene, were now a more convenient alternative. The celebrity hairdresser was Mr Teasie-Weazie.

Many Christmas presents were solved with a gift set of bath cubes, talcum powder and lavender water. Every toiletry manufacturer designed decorative boxes to enhance their value and even included a small card for the giver to inscribe his or her name.

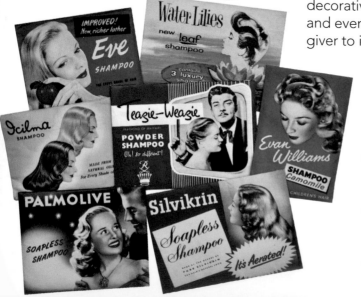

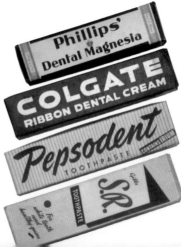

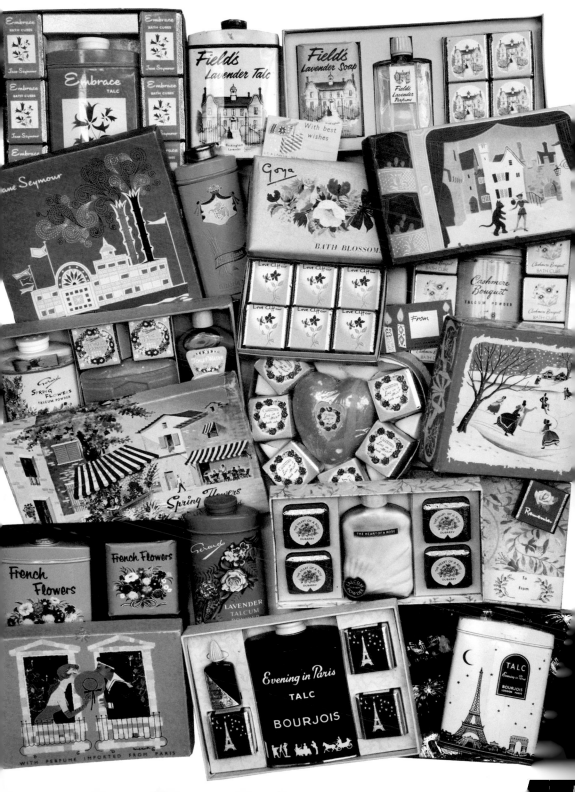

Novelty Soaps

Generations of youngsters have enjoyed receiving their favourite character made out of soap. On Christmas Day, the present was unwrapped to reveal the box and, with mounting anticipation, the painted model inside. The question was, how long would it be before Mother insisted the soap was used? Here is the evidence that many survived.

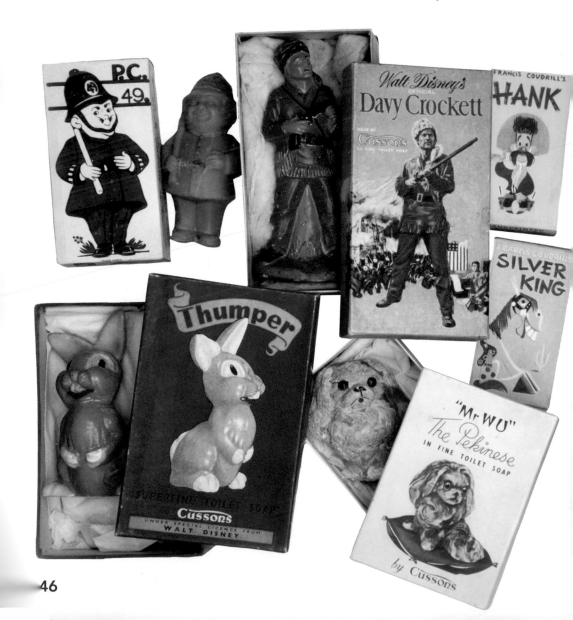

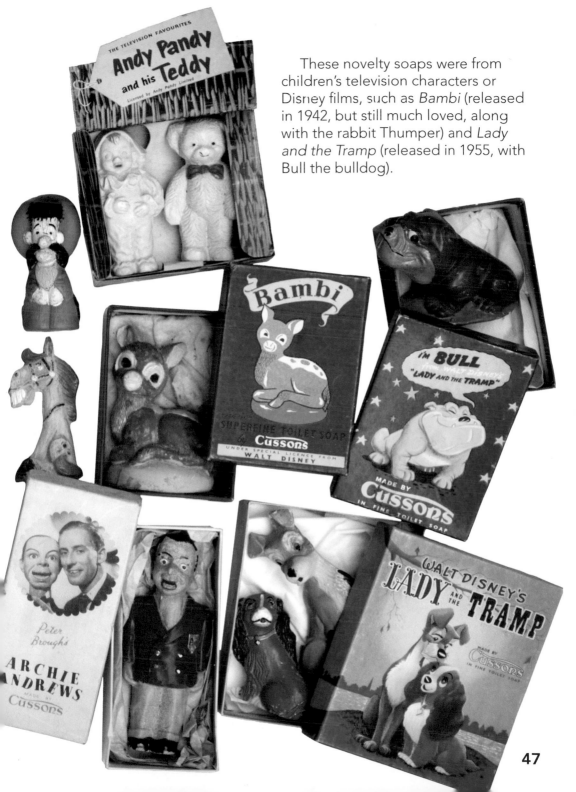

These novelty soaps were from children's television characters or Disney films, such as *Bambi* (released in 1942, but still much loved, along with the rabbit Thumper) and *Lady and the Tramp* (released in 1955, with Bull the bulldog).

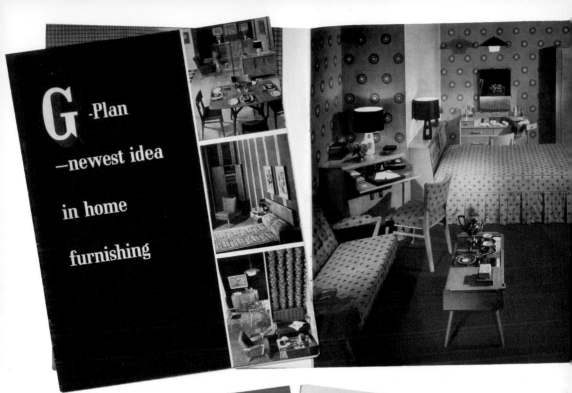

G-Plan

—newest idea

in home

furnishing

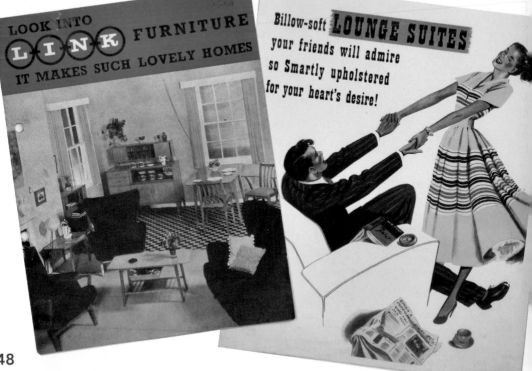

LOOK INTO **L·I·N·K** FURNITURE
IT MAKES SUCH LOVELY HOMES

Billow-soft **LOUNGE SUITES**
your friends will admire
so Smartly upholstered
for your heart's desire!

Furniture and Fabrics

'It's new ... it's sophisticated ... it's G-Plan.' The post-war generation craved furniture that looked more than just functional – they wanted style. To the rescue came G-Plan in 1953. 'Here at last is an entirely new idea of home furnishing – an idea that is so simple, so practical, and above all so attractive, that it has caught on like wildfire all over the country.'

Two new surfaces took off during the 1950s. Formica was made in over fifty modern colours and patterns that 'will absolutely transform your home ... not only in the kitchen, but every room'. The other surface was Fablon, 'the finest range of plastics ever produced to beautify your home and gladden your heart'.

Dunlopillo gave a luxury feel to wall-to-wall carpeting, while the Readicut book of rugs provided something useful and satisfying for housewives to create in the evening ... before television took over.

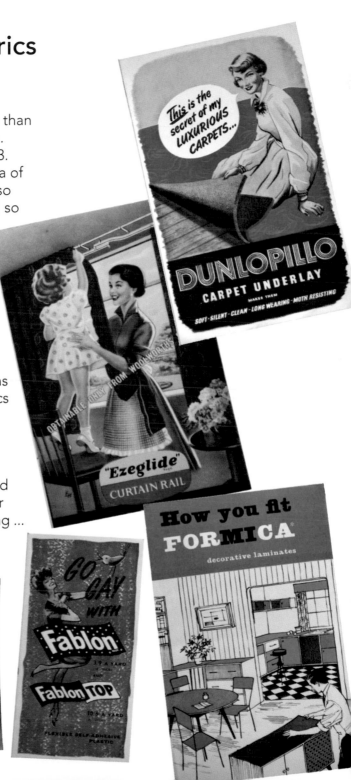

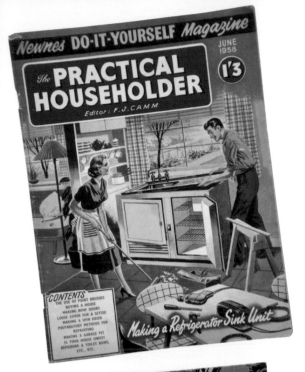

Do-It-Yourself

During the 1950s, a new culture of DIY emerged. With pipe in mouth or a steely smile, the man of the house was encouraged to indulge in home improvements. The launch of *Practical Householder* in 1955, *Do It Yourself* magazine in 1957 and *Homemaker* in 1959 propelled major DIY projects to the top of the lifestyle 'must do' list.

Not to be left out, housewives were portrayed as being an important part of this revolution. However, the power drill (originally developed decades earlier for industrial purposes) was still the man's domain, and, for boys, the junior handyman's kit encouraged a son to be 'just like my Dad!' – except the kit was made from plastic. Women were, seemingly, particularly good at laying floor tiles and handling a 'speedy' paint roller while also being the attentive housewife – sweeping up or being consulted on the colour scheme.

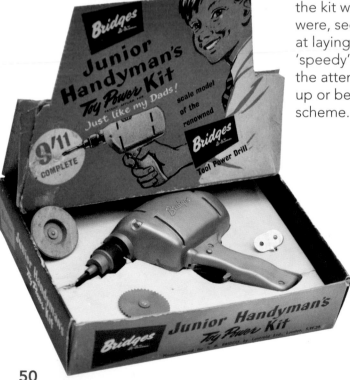

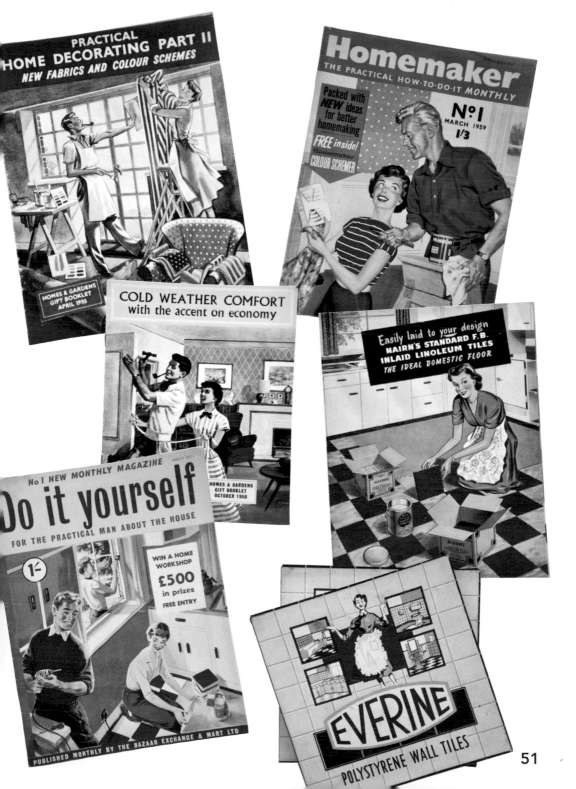

PRACTICAL
HOME DECORATING PART II
NEW FABRICS AND COLOUR SCHEMES

HOMES & GARDENS
GIFT BOOKLET
APRIL 1955

Homemaker
THE PRACTICAL HOW-TO-DO-IT MONTHLY

Packed with **NEW** ideas for better homemaking

Nº I
MARCH 1959
1/3

FREE inside!
Homemaker
COLOUR SCHEMER

COLD WEATHER COMFORT
with the accent on economy

HOMES & GARDENS
GIFT BOOKLET
OCTOBER 1958

Easily laid to your design
NAIRN'S STANDARD F.B.
INLAID LINOLEUM TILES
THE IDEAL DOMESTIC FLOOR

No1 NEW MONTHLY MAGAZINE
Do it yourself
FOR THE PRACTICAL MAN ABOUT THE HOUSE

1/-

WIN A HOME
WORKSHOP
£500
in prizes
FREE ENTRY

PUBLISHED MONTHLY BY THE BAZAAR EXCHANGE & MART LTD

EVERINE
POLYSTYRENE WALL TILES

51

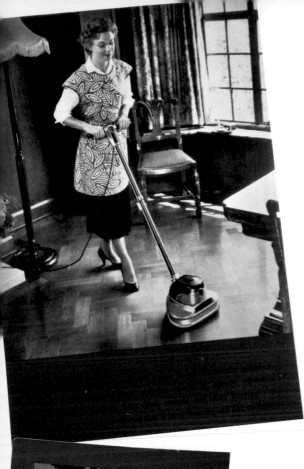

Home Cleaning

The revolutionary Hoover Constellation came to the aid of British housewives in the mid 1950s, bringing a space-age look to the home: 'It floats on its own cushion of air' along with the exclusive disposable bag that flipped out so easily without fuss or messy spilling.

The upright Hoover had arrived from the USA in 1919, the same year that the 'It Beats, as it Sweeps, as it Cleans' slogan was adopted. By the 1950s, most households owned an electric vacuum cleaner. The dainty Ewbank sweeper was a handy alternative, just push, and no electric cord. Gliding over the floor was the Electrolux polisher, for Lino, tiled or stained floors or the upmarket wood parquet flooring, 'floating suspension of the brushes self-adjusting to irregularities in the floor surface'.

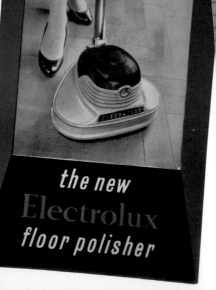

the new
Electrolux
floor polisher

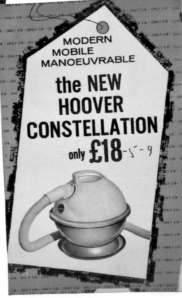

MODERN
MOBILE
MANOEUVRABLE

the NEW
HOOVER
CONSTELLATION
only £18-5-9

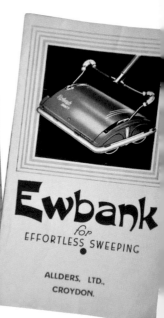

Ewbank
for
EFFORTLESS SWEEPING

ALLDERS, LTD.,
CROYDON.

A houseproud woman is a "Hooverproud" woma[n]

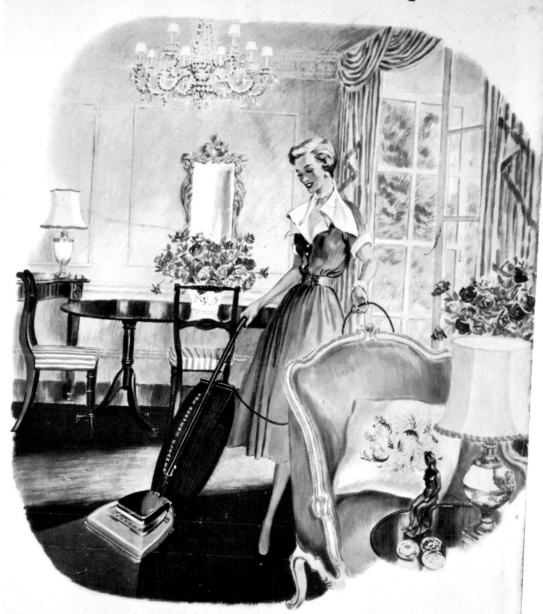

The HOOVER CLEANER

REGD. TRADE MARK

It BEATS... as it Sweeps... as it Cleans

Washing Clothes

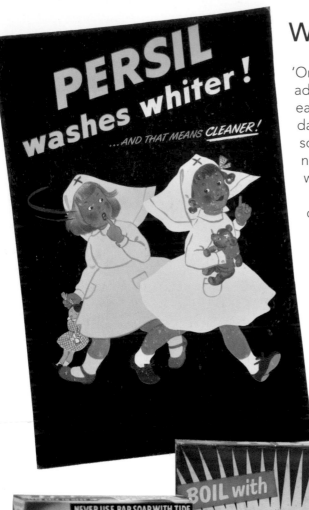

'Once I've switched on the Bendix and added the soap, I'm free to take my ease. It really does mean a workless day. No filling, no emptying, no scrubbing, no wringing, no splashing, no laundry bills, and better washing without hands ever touching water!'

Every washing machine had its own sales patter. For instance, Burco claimed it, 'washes thoroughly because the gearbox driven agitator really moves the clothes – not just the water – so there's sufficient action to loosen dirt and grime'. Clothes washing was so much easier, and in the early 1950s new detergent soap powders like Tide, Surf and Omo provided greater efficiency that included Stergene's suds-free innovation. Persil continued to turn heads with its washing whiter poster campaign.

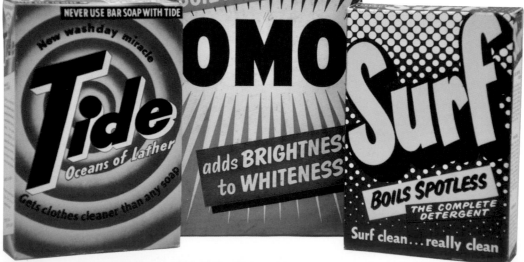

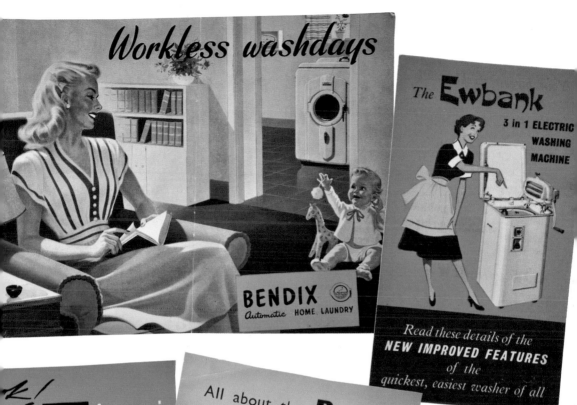

Workless washdays

BENDIX *Automatic* HOME LAUNDRY

The Ewbank
3 in 1 ELECTRIC WASHING MACHINE

Read these details of the
NEW IMPROVED FEATURES
of the
quickest, easiest washer of all

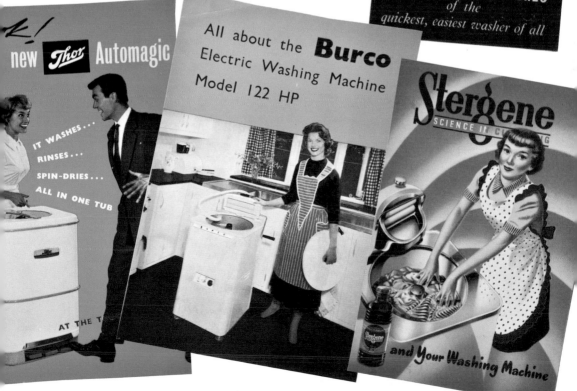

new **Thor** Automagic

IT WASHES...
RINSES...
SPIN-DRIES...
ALL IN ONE TUB

AT THE T

All about the **Burco**
Electric Washing Machine
Model 122 HP

Stergene
SCIENCE IN CLEANING

and Your Washing Machine

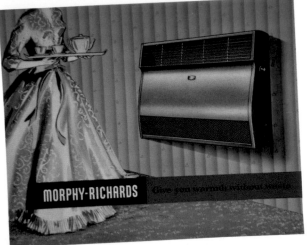

MORPHY-RICHARDS — *Give you warmth without waste*

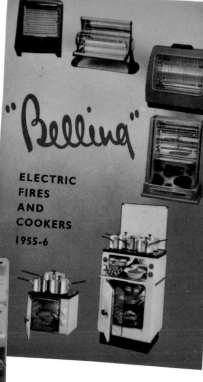

"*Belling*"

ELECTRIC
FIRES
AND
COOKERS
1955-6

"*Belling*" WAVERLEY FIRE

An outstanding and impressive Electrical fire which is particularly suitable for the lounge or dining-room. It is large enough to cover any modern fireplace opening and the heating elements can be of the firebar or reflector type as preferred.

3 kW size (for large rooms). Uses 1, 2 or 3 units per hour.
22½" wide × 26" high × 8½" deep. 27½ lb.
FIREBAR TYPE (Beige finish) No. 263 £22 7s 7d inc. tax
REFLECTOR TYPE (Beige finish) No. 264 £23 8s 1d inc. tax
FIREBAR TYPE (Electro-plated Bronze)
 No. 263P £28 0s 4d inc. tax
REFLECTOR TYPE (Electro-plated Bronze)
 No. 264P £29 0s 10d inc. tax

Supplied with six feet of flex.

No. 264

26

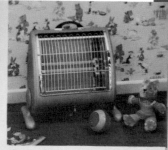

"*Belling*" HOMEGUARD FIRE

This fire has been designed for those who prefer a fire with specially protected elements. It incorporates a switch which automatically cuts off the current in the event of the fire being knocked over, thus affording complete protection for both young and old. The fire can be adjusted to project heat in any direction. A heat-resisting handle is fitted so that it may be easily carried from room to room.

2 kW size (for medium rooms). Uses 1 or 2 units per hour.
19" wide × 19" high × 9½" deep. Weight 19 lb.

 No. 155 £13 13s 4d inc. tax

Finishes: Silver, Silver Bronze, Silver Green.
Supplied with six feet of flex.

19

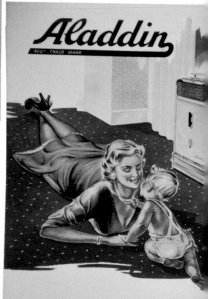

Aladdin
REG⁰ TRADE MARK

in every room

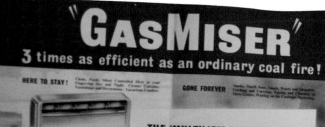

"GASMISER"
3 times as efficient as an ordinary coal fire!

HERE TO STAY! Clean, Fresh, Silver Controlled Heat at your Finger-tips Day and Night. Cleaner Curtains, Furnishings and Decorations. Luxurious Comfort.

GONE FOREVER Smoke, Smell, Soot, Smuts, Shame and Draughts. Fetching and Carrying, Laying and Cleaning of Dirty Grates. Waiting on the Coalman. Rekindling.

THE "MULTYJET" CONVECTOR

The outstanding development of the "Multyjet" Hot Air Convector incorporated in the design of the GASMISER now makes it possible to use gas for Continuous Room Heating at a cost lower than that of Coal. This amazingly efficient Convector will heat 1,330 cubic feet of air space at a temperature of 200° Fahrenheit per hour. In Double Jet action ensures the Maximum of heat to the low and the Minimum of heat into the room—only the GASMISER has this feature. And the substance to throw into the "Multyjet" Convector. As its various adjustments the GASMISER will give you only a Controlled Heat, but will always maintain the room atmosphere Fresh as well as Warm.

The Company which gave you Britain's Best Cooker, the new world-famous A127 Cooker, with the Folderaway for Level Grill, introduces a new era in room heating, comfort and economy.

ONLY THE GASMISER—BRITAIN'S BEST ROOM HEATER—HAS THE "MULTYJET" CONVECTOR

PRICE £29.18.10 TAX PAID

Cannon GASMISER

Heating the Home

With central heating a distant aspiration for most, the electric heater, gas fire or Aladdin blue flame stove that 'burns steadily and completely without attention for 15 hours on 1 gallon of paraffin', was as much a part of winter as Jack Frost on the windowpanes on freezing mornings.

Coal fires were on the way out as the Gas Miser provided 'clean silent healthy heat at a price you can afford to pay!' For those who needed the nostalgic comfort of a coal fire without real coal, electric fires with 'realistic coal' were available. The ultimate in warmth came from an electric blanket – so it was time to throw out the hot water bottle ... except there might be a power cut.

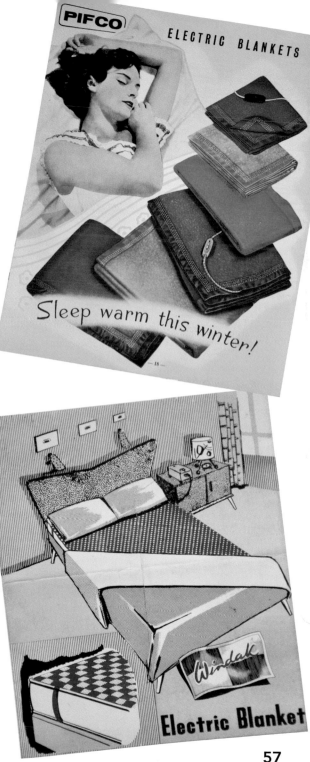

PIFCO ELECTRIC BLANKETS

Sleep warm this winter!

— 18 —

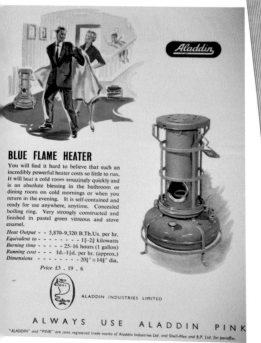

BLUE FLAME HEATER

You will find it hard to believe that such an incredibly powerful heater costs so little to run. It will heat a cold room amazingly quickly and is an absolute blessing in the bathroom or dining room on cold mornings or when you return in the evening. It is self-contained and ready for use anywhere, anytime. Concealed boiling ring. Very strongly constructed and finished in pastel green vitreous and stove enamel.

Heat Output - - - 5,870–9,320 B.Th.Us. per hr.
Equivalent to - - - - - - - 1½–2½ kilowatts
Burning time - - - - - 25–16 hours (1 gallon)
Running cost - - - 1d.–1½d. per hr. (approx.)
Dimensions - - - - - - - 20½″ × 14½″ dia.

Price £5 . 19 . 6

ALADDIN INDUSTRIES LIMITED

ALWAYS USE ALADDIN PINK

"ALADDIN" and "PINK" are joint registered trade marks of Aladdin Industries Ltd. and Shell-Mex and B.P. Ltd. for paraffin.

Electric Blanket

Radio

For news, information, music and entertainment, the radio was everyone's constant companion. During the 1940s' wartime uncertainties, the radio had been an essential component of keeping Britain's morale high. In the 1950s, Marconiphone's T24 DAB was the versatile go-anywhere portable radio. 'See how elegantly this charming attaché case of a set will sit on your sideboard, your kitchen dresser, your dressing table, your garden bench! There is no other set which is at once so light, so slight, so versatile and so very efficient.'

Radio was the launch pad for many TV stars, including *Hancock's Half*

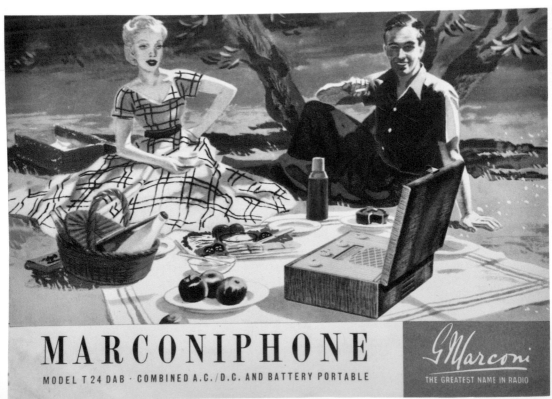

MARCONIPHONE
MODEL T 24 DAB · COMBINED A.C./D.C. AND BATTERY PORTABLE

GMarconi
THE GREATEST NAME IN RADIO

Hour and the *Frankie Howerd Show*. Tuning in to the Home Service, Light Programme or Third Programme, listeners found their favourites – *The Goons* (Peter Sellers, Spike Milligan, Harry Secombe), *The Navy Lark* (including Leslie Phillips), *Round the Horn* (Kenneth Williams) and that unending story of country folk *The Archers*, which began in 1951. If you wanted pop music, you had to switch on to Radio Luxembourg.

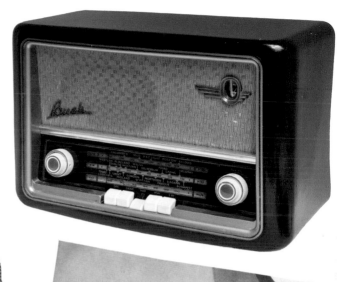

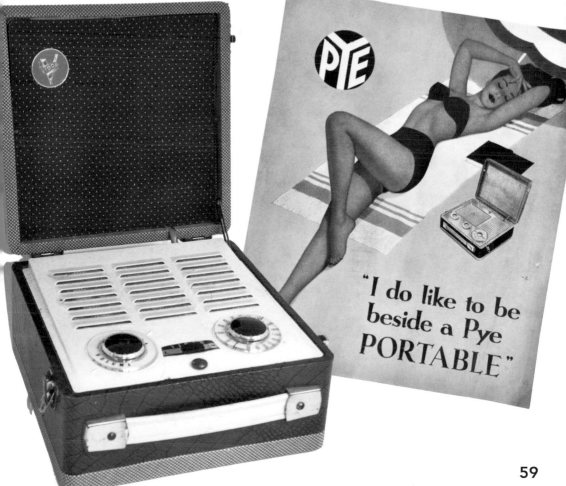

"I do like to be beside a Pye PORTABLE"

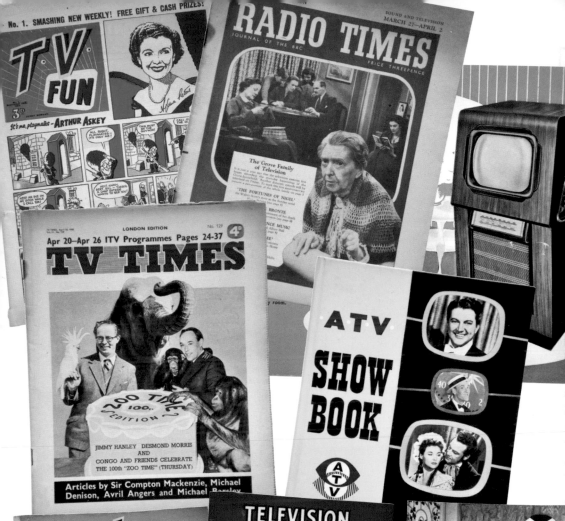

No. 1. SMASHING NEW WEEKLY! FREE GIFT & CASH PRIZES!

T·V· FUN

3D

It's me, playmates—ARTHUR ASKEY

SOUND AND TELEVISION
MARCH 27—APRIL 2

RADIO TIMES

JOURNAL OF THE BBC
PRICE THREEPENCE

The Grove Family
of Television

THE FORTUNES OF NIGEL

LONDON EDITION No. 129

Apr 20—Apr 26 ITV Programmes Pages 24-37 4d

TV TIMES

ZOO TIME
100th
EDITION

JIMMY HANLEY DESMOND MORRIS
AND
CONGO AND FRIENDS CELEBRATE
THE 100th "ZOO TIME" (THURSDAY)

Articles by Sir Compton Mackenzie, Michael
Denison, Avril Angers and Michael Barsley

ATV
SHOW
BOOK

ATV

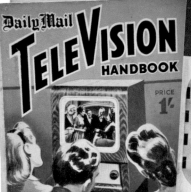

Daily Mail

TeleVision
HANDBOOK

PRICE 1/-

ALEXANDRA PALACE AND
SUTTON COLDFIELD

HINTS ON RECEPTION & TUNING
TELEVISION PERSONALITIES
QUESTIONS AND ANSWERS ON TELEVISION

TELEVISION
PICTURE FAULTS
By John Cura & Leonard Stanley

TELEVISION
BBC
SERVICE

CONTAINING 150 ACTUAL SCREEN PHOTOGRAPHS

SIMPLE EXPLANATIONS FOR THE HOME VIEWER.
TECHNICAL EXPLANATIONS FOR THE EXPERT

3/6

PUBLISHED BY TELEVISION TIMES LTD.

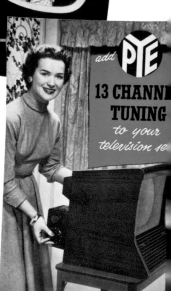

add PYE

13 CHANNEL
TUNING
to your
television se

Television

Only available to London's few before WWII, television would be a catalyst for many changes throughout the 1950s. Just 150,000 homes had a set in 1950, but as coverage reached more of Britain, so ownership increased. The Coronation of 1953 encouraged viewers, but the arrival of commercial television on 22 September 1955 represented a breakthrough. By the end of the decade, some 60 per cent of homes had a TV set, and most preferred to watch ITV's selection.

While the *Radio Times* covered the BBC, the *TV Times* was the weekly guide for Independent TV, and *TV Mirror* was also launched in 1955 'for viewers and listeners'.

Initially, TV sets could only receive one channel, so in preparation for more channels, Pye devised the Type 47 television adaptor unit, which made an optimistic forecast:' You too can now have 13 Channel Tuning – without the expense of a new set.' Of course, TV technology had not been perfected, so after hitting the goggle box and twiddling the controls and aerial, there was advice in handbooks that talked technical terms like 'contrast', 'frame hold' and 'horizontal shift'.

Reception restored, television was all about fun – with *The Grove Family* (the UK's first soap opera), or *Zoo Time* with Desmond Morris, which, along with David Attenborough's *Zoo Quest*, meant boom time for zoo visits.

By 1953, the buzzword of the moment was 'TV', little wonder that a new comic was called *TV Fun*, even though there was little reference to TV inside; the pin-up on the cover was Sylvia Peters, one of only two women announcers on the BBC.

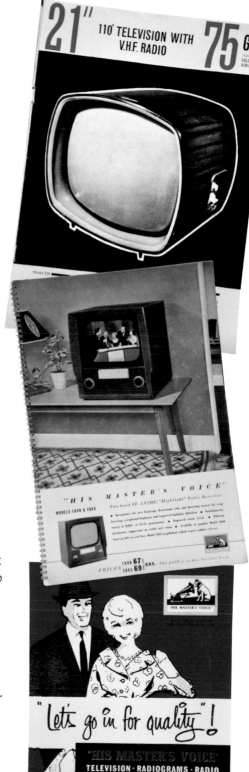

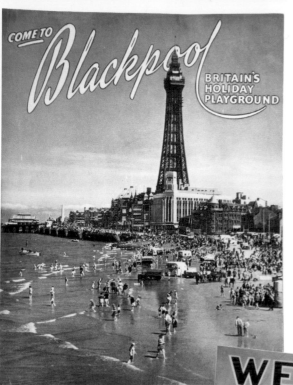

Seaside Destinations

'From the moment you arrive, Whitley Bay says "Glad to see you". You may not know it then, but you are starting out on what may easily be the happiest holiday of them all. You'll enjoy the miles of golden sands, children will love this paradise, the Spanish city entertainment park, colourful gardens, fun and games.'

Seaside brochures clamoured to offer it all, but which to choose – Southsea or Southend, Weston-Super-Mare or Whitley Bay? What did you want: carnivals and regattas,

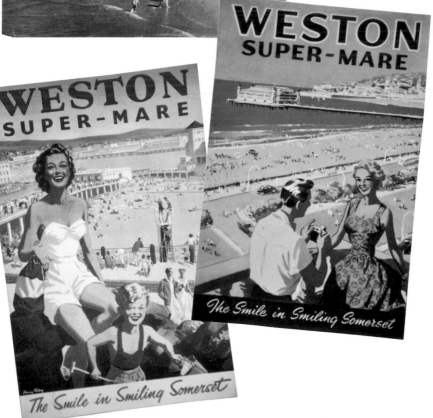

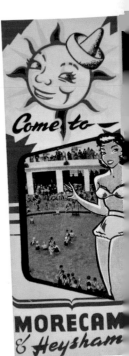

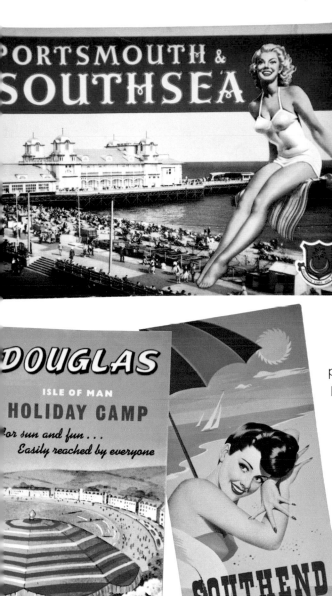

promenades and concert parties, a boating lake, sporting facilities and beauty contests, pavilion and winter gardens, or ballroom and grand pier? Or was it the spacious seafront with miles of sandy beaches that would be the deciding factor?

Ultimately, it might be a return visit to familiar surroundings, another trip to Blackpool, 'Britain's holiday playground' with its iconic tower, built in 1894, emulating the Eiffel Tower constructed just five years earlier.

Rail to the Coast

The anticipation of the annual family fortnight by the seaside was heightened by the excitement of travelling on a steam train. Packed and ready to go? Don't forget the Brownie camera or the sunglasses. The *British Railways Holiday Guide* contained every destination and accommodation address. Would it be the 'leisure and pleasure' of Burnham-on-Sea (the station was opened in 1858, but closed in 1962) or the 'entertainment, amusements and amenities' with everything included in the all-in tariff of Butlins (set up by Billy Butlin in 1936).

On the cover of *John Bull* magazine, happy holidaymakers return with glorious suntans, while the pale faces of the next passengers look on with hope that they will have equally good weather. Another advantage for youngsters travelling by rail was the benefit of trainspotting during the journey – a social activity that had begun in the 1940s.

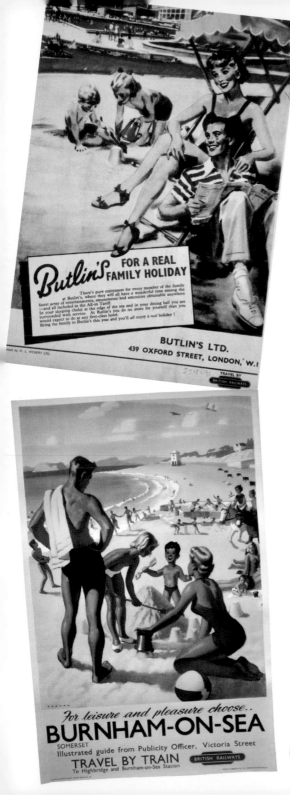

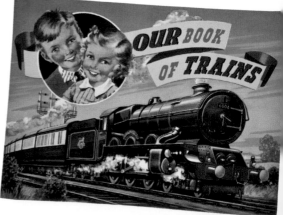

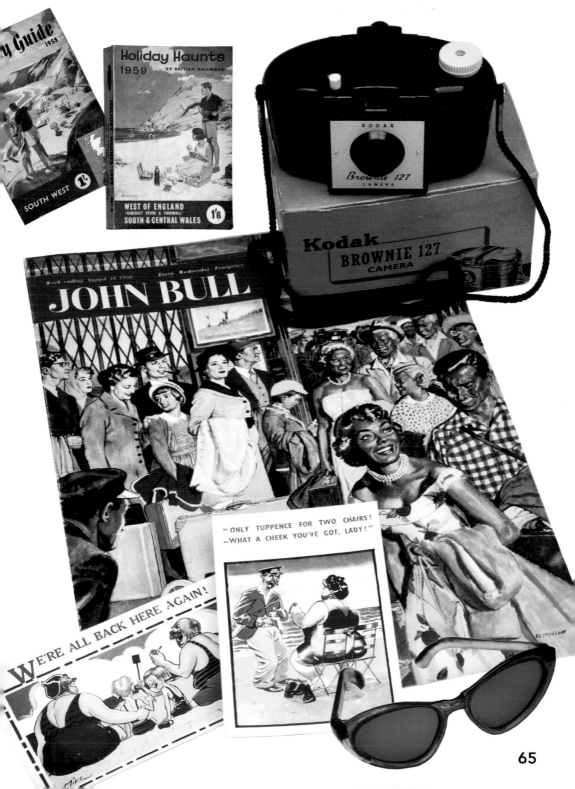

Holidays Abroad

Your luggage now became a subtle way of showing how well travelled you were, as it gathered more stickers from each holiday destination – France, Italy, Belgium, Switzerland – travelling abroad was becoming more affordable.

A motorcoach trip ticked most of the boxes for many, to 'smooth away all the problems'; there was nothing to worry about, 'baggage, tips, porters, meals, all clerical, customs and booking difficulties are smoothed away and taken care of completely by our competent, experienced couriers, whose whole endeavour is to see that your holiday runs smoothly and happily throughout ... thrilling, always interesting, yet ever restful!'

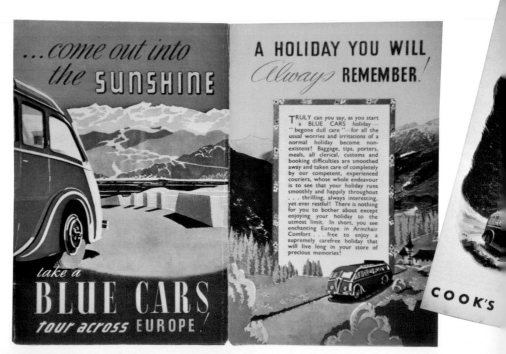

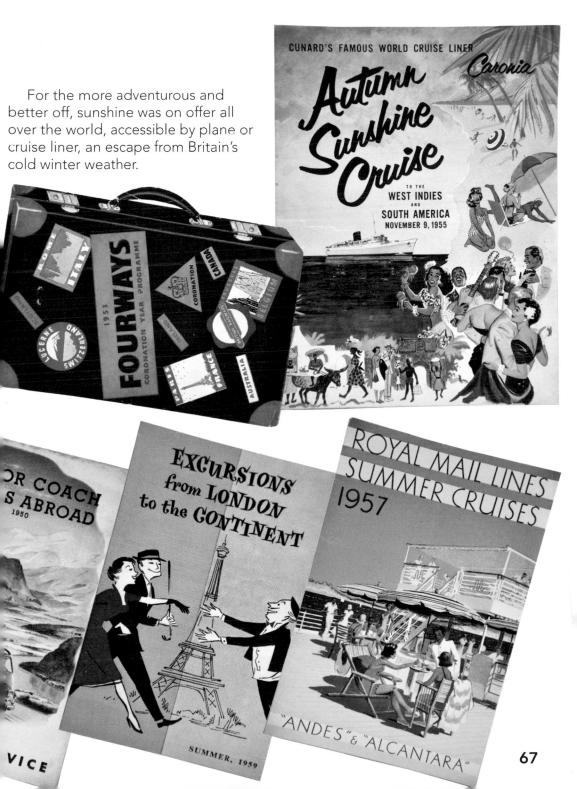

For the more adventurous and better off, sunshine was on offer all over the world, accessible by plane or cruise liner, an escape from Britain's cold winter weather.

CUNARD'S FAMOUS WORLD CRUISE LINER

Caronia

Autumn Sunshine Cruise

TO THE
WEST INDIES
AND
SOUTH AMERICA
NOVEMBER 9, 1955

FOURWAYS
CORONATION YEAR PROGRAMME
1953

OR COACH
S ABROAD
1950

EXCURSIONS
from LONDON
to the CONTINENT

SUMMER, 1959

ROYAL MAIL LINES
SUMMER CRUISES
1957

"ANDES" & "ALCANTARA"

VICE

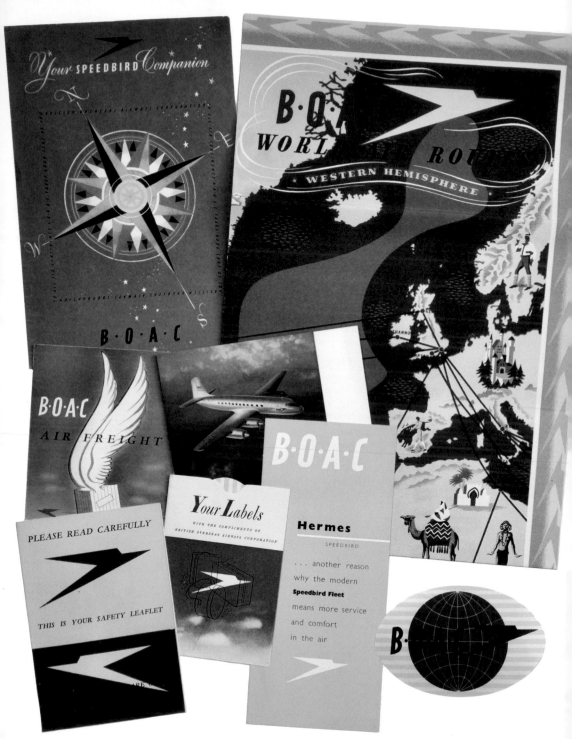

Flying

'The Elizabethan offers a high standard of comfort with its fully pressurized, air-conditioned, soundproofed cabin. It's high-wing position and large windows afford a fine view of the countries over which you fly.' British European Airways (BEA) added the Elizabethan to its fleet in 1952, flying it until 1958. It had been developed by Airspeed, having originally been called Ambassador, but renamed by BEA.

The sky was full of exotic-sounding aircraft – de Havilland's Heron and Comet, the Bristol Britannia, the Handley Page Hermes, the Lockheed Constellation and Boeing's Monarch Stratocruiser, the first to fly a scheduled route to New York by British Overseas Airways Corporation (BOAC). Transatlantic aircraft carried BOAC's Speedbird logo on their tail fins.

Always keen for information, travellers could purchase the London Airport booklet (opened for civil aviation in 1946, and renamed Heathrow in 1966). BOAC provided a folder full of information, but for short haul a single flight bulletin was it, and 'please pass on quickly'.

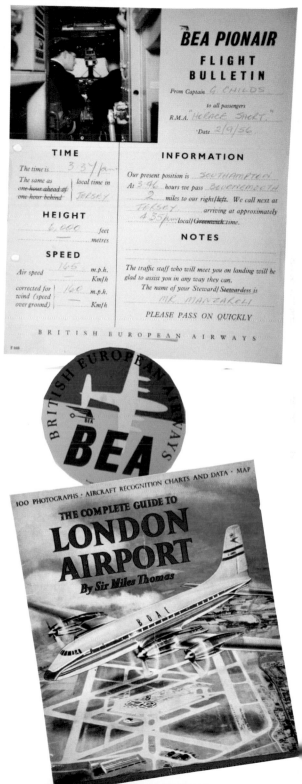

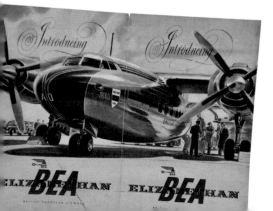

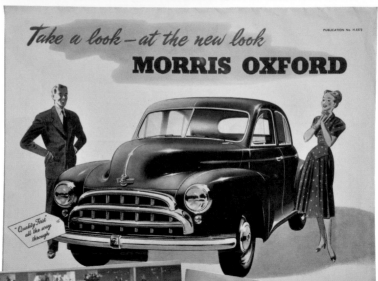

Take a look — at the new look
MORRIS OXFORD

PUBLICATION No. H.9373

"Quality first all the way through"

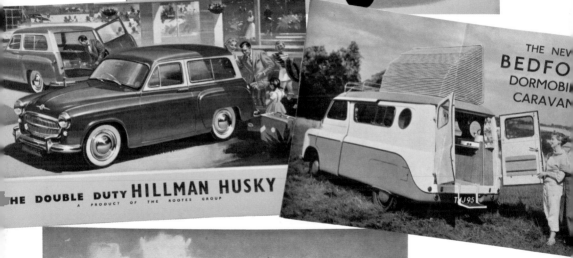

HE DOUBLE DUTY **HILLMAN HUSKY**
A PRODUCT OF THE ROOTES GROUP

THE NEW
BEDFORD
DORMOBILE
CARAVAN

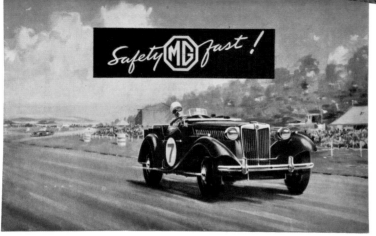

Safety MG fast!

Motoring

The art of selling a car involved seduction. The glossy brochures tempted the buyer with images of polished bodies and gleaming chrome bumpers, the advertiser's artwork angled to ensure the most captivating profile. 'Drive in style with comfort, performance, reliability and economy' was the sales pitch of the Morris Oxford in 1955. The Triumph TR3 sports car boasted there was nothing to beat the 'feel of the swift, surging power and punch of its 2 litre engine – then you'll know what inspired motoring really is!'

In 1956 the Land Rover long station wagon was launched, in 1954 the Hillman Husky ('saloon car comfort plus carrying capacity') and in 1957 the Bedford Dormobile Caravan ('the freedom of travelling without the need for towing a caravan'). By the end of the decade, half of all families owned a motor car.

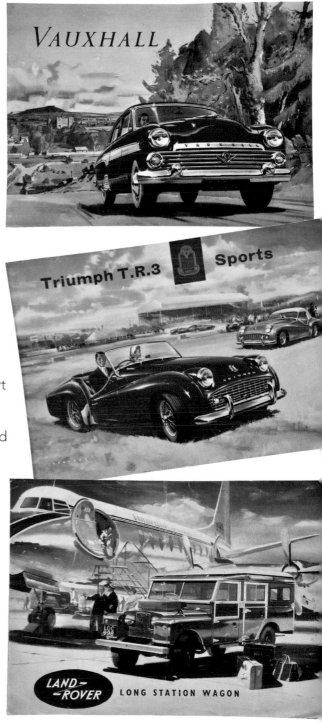

VAUXHALL

Triumph T.R.3 Sports

LAND ROVER LONG STATION WAGON

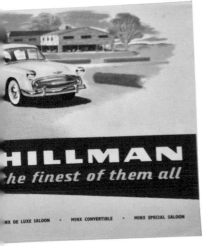

HILLMAN
the finest of them all

MINX DE LUXE SALOON · MINX CONVERTIBLE · MINX SPECIAL SALOON

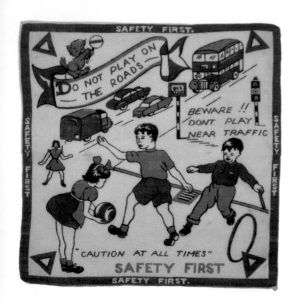

Road Safety

'When crossing remember your kerb drill: look right, look left, then right again – wait until all traffic has passed and then walk over quickly.' The Royal Society for the Prevention of Accidents (RoSPA) had been founded in 1917, but as ownership increased in the 1950s and cars were driven faster, there were more pedestrian accidents, especially among children. RoSPA promoted safety messages through posters, leaflets, booklets, handkerchiefs, novelty cards and even a game called Tiddley (inspired by the game of Tiddley Winks – not being tipsy).

Oxo produced a couple of road safety painting books. The *Daily Mail* sponsored Enid Blyton's *Road Safety Colouring Book*, 'A stands for Accident, Ambulances too, You must take care or it may come for you.'

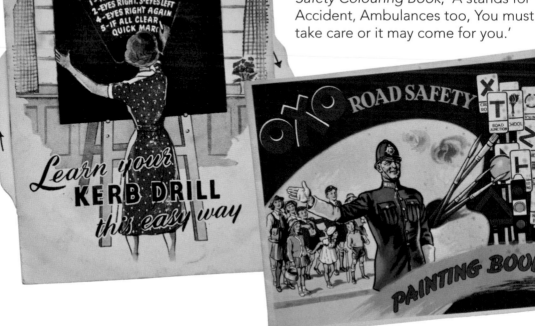

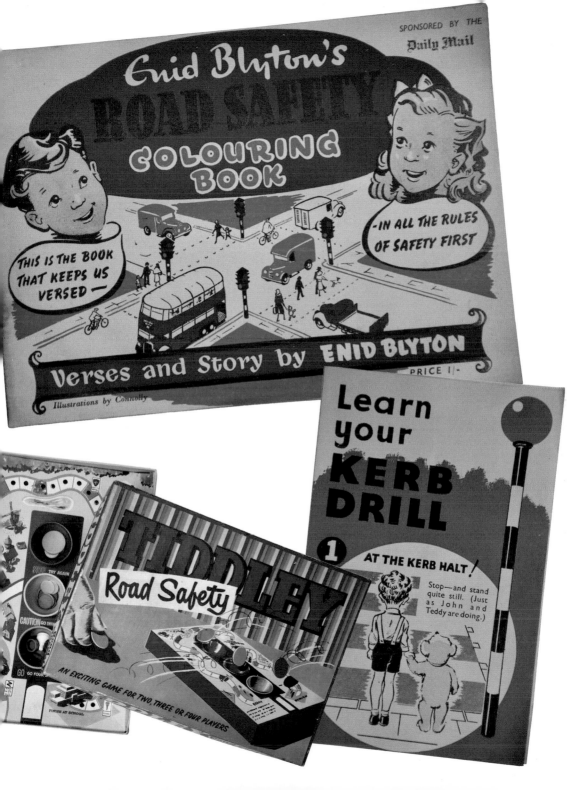

Motorbikes

The motorbike industry had now been revving up for over 50 years, and in the 1950s, motorcycles were more popular than ever, portrayed with the pulling power to put a girl on the pillion seat.

But now from Italy came scooters – economical at 140 miles to the gallon – the Vespa and the Lambretta. Here was an alternative, but which to choose? Motorbikes had the macho edge, but scooters were easier to drive with simple controls that gave the rider confidence. They were also safe to drive, 'perfect balance is maintained with a centrally-mounted engine giving a low centre of gravity, which ensures complete safety under all road conditions'.

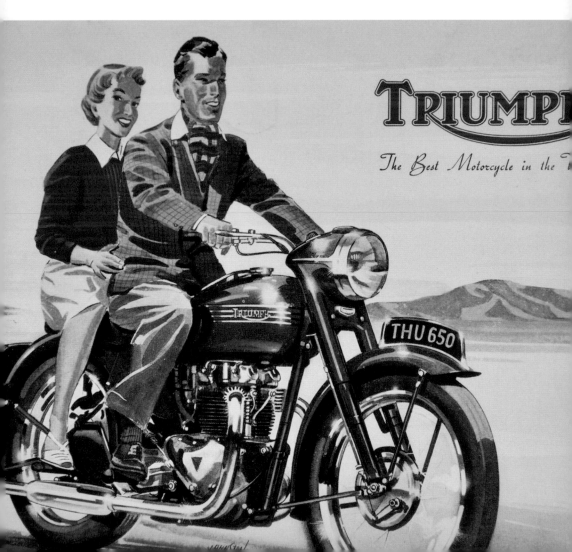

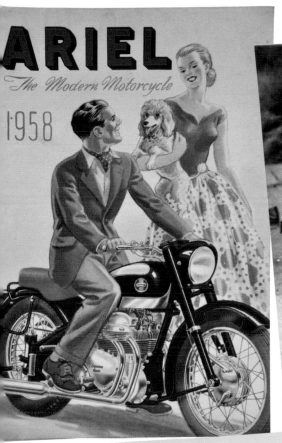

ARIEL
The Modern Motorcycle
1958

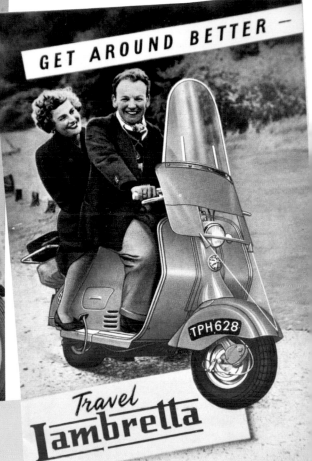

GET AROUND BETTER —

Travel
Lambretta

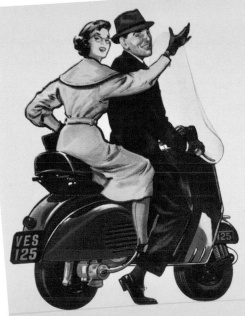

VES 125

CHOOSE
Vespa
AND GET THE BEST

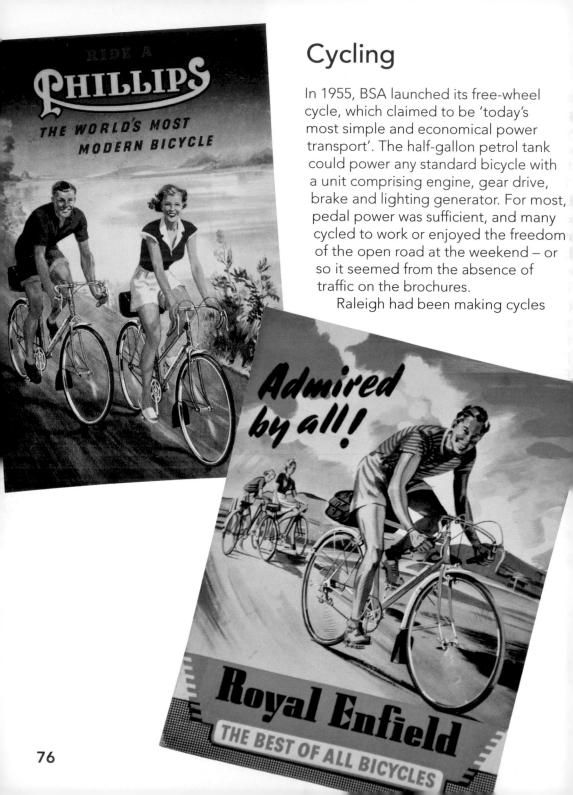

Cycling

In 1955, BSA launched its free-wheel cycle, which claimed to be 'today's most simple and economical power transport'. The half-gallon petrol tank could power any standard bicycle with a unit comprising engine, gear drive, brake and lighting generator. For most, pedal power was sufficient, and many cycled to work or enjoyed the freedom of the open road at the weekend – or so it seemed from the absence of traffic on the brochures.

Raleigh had been making cycles

RIDE A
PHILLIPS
THE WORLD'S MOST MODERN BICYCLE

Admired by all!

Royal Enfield
THE BEST OF ALL BICYCLES

since 1887, when twelve workers produced 160 bicycles a year. Seventy years on, 7,500 workers made over a million cycles a year. Royal Enfield first made a bicycle in 1893, and in 1952 considered theirs to be 'the best of all bicycles', which perhaps conflicted with Phillips' claim of making 'the world's most modern bicycle'. Manufacturers were clearly uncertain as to whether to identify their models with numbers (sports men's model P13, sports tourist model 23 gents) or go for a punchy brand name like Phantom, Kingfisher, Boulevard, Firefly or Mayfly.

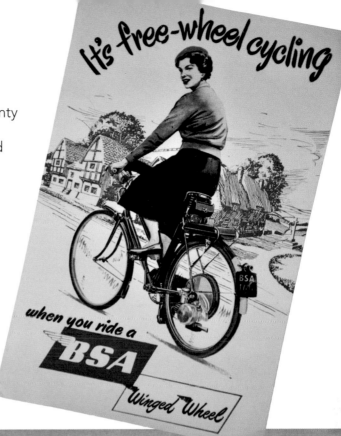

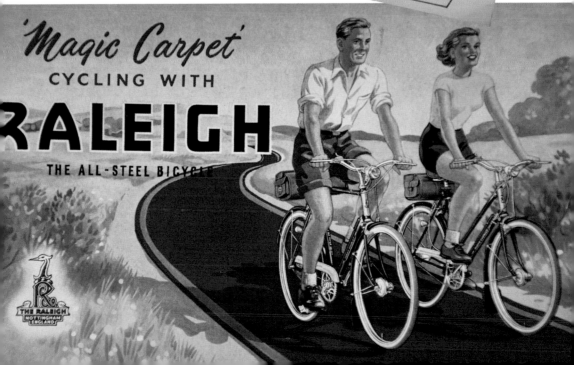

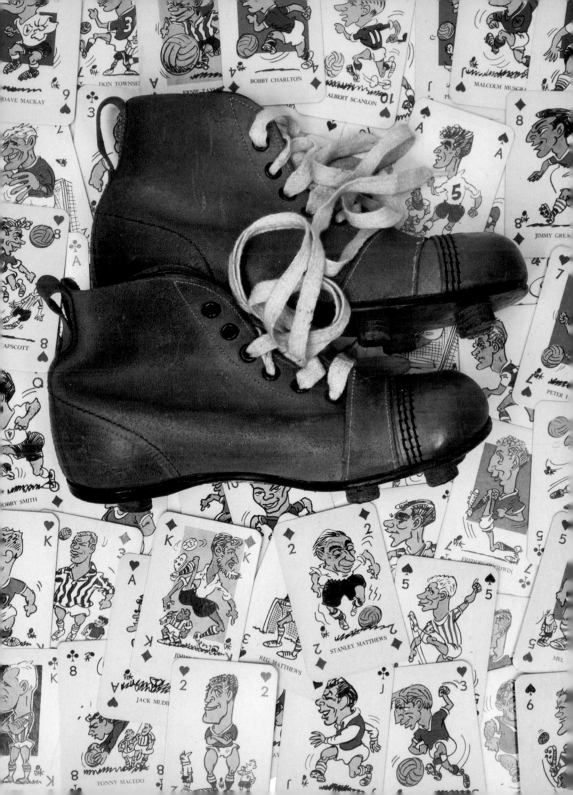

Football

The national sport, football, had some forty million attendances a year at the beginning of the decade. Based on predicting the football match scores, many people participated in the dream of winning on the pools, begun in 1923 by Littlewoods, and followed by Vernons and Zetters. In 1950 the largest winner won £100,000; in 1957 the highest winnings reached twice that amount.

It was in 1954 that the 'super new paper for boys', *Tiger*, was launched, featuring Roy of the Rovers – Roy Race who played for Melchester Rovers. 'Roy's twinkling feet kept the ball under control as he was tackled.' In reality, the stars of the 1950s were footballers like Stanley Matthews 'the wizard of the dribble' who played for Blackpool for 14 years; Billy Wright, whose whole career was with Wolverhampton Wanderers and who was the first footballer in the world to earn a hundred international caps; Tom Finney, who was recognized as the greatest all-rounder and played for Preston North End (he was never booked, sent off or even ticked off by a referee); and Tommy Docherty, who played for Scotland 25 times between 1951 and 1959 and also for Preston North End.

The Munich air disaster of 1958 killed eight Manchester United players, known as Busby's Babes; Bobby Charlton survived. In the same year, BBC's *Grandstand* began.

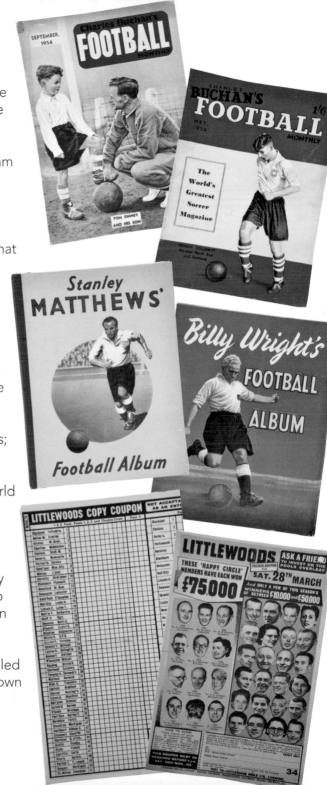

34

Live Entertainment

Before television had totally gripped the nation with home entertainment, there had been a long tradition of going to music halls, variety theatres and the circus, fun for all the family. The stage was where performers perfected their craft – an early entry into television could prove disastrous, as Morecambe and Wise discovered with a TV series called *Running Wild* in 1954. They regained their TV appeal when they appeared on the *Winifred Atwell Show* in 1956. The London Palladium had opened in 1915 with pantomimes and revues. In 1955, *Sunday Night at the London Palladium* took off on ITV, hosted by Tommy Trinder (1955–58) and then Bruce Forsyth (1958–64).

On the bill for Newcastle's Empire Theatre was the comedian and variety entertainer Albert Modley, alongside the husband-and-wife team Pearl Carr and Teddy Johnson, who came second in the Eurovision Song Contest for 1959 with 'Sing, Little Birdie'. Pantomime was a Christmas treat for many. Tom Arnold was dubbed the king of panto for his productions, especially the most lavish, staged on ice at Wembley Arena; his circus at Harringay (from 1947 to 1958 was equally memorable.

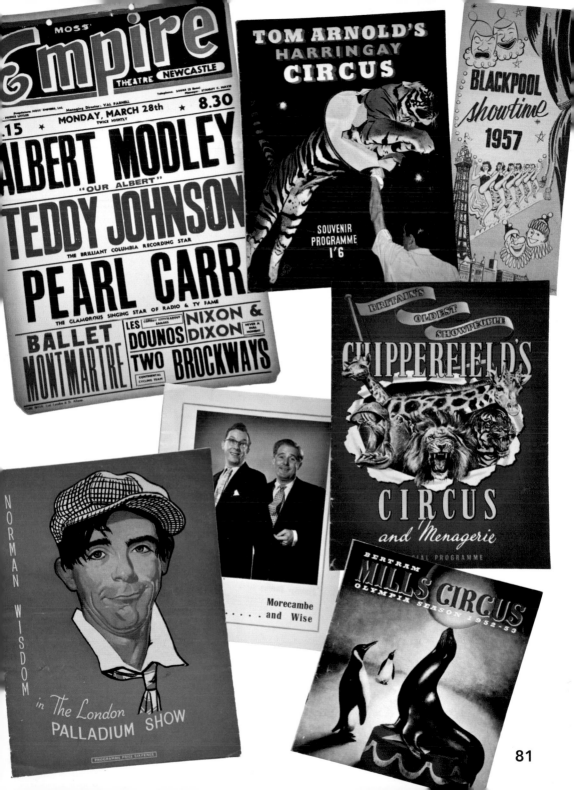

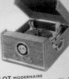
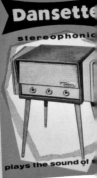
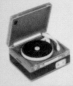

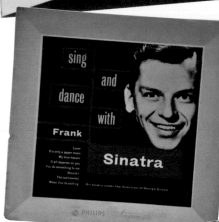

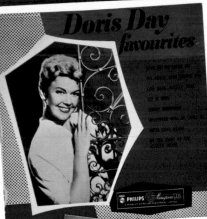

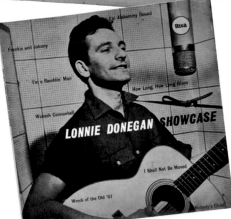

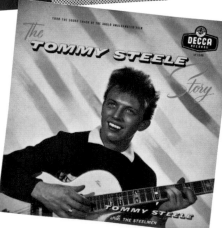

Records and Players

With a stack of records, every teenager wanted a record player, or at least a friend who had one. Sitting on the floor was the way for 'cool cats' to 'dig' this new 'groovy' music that was really 'hip' (from hip-hop). And, of course, playing the same record loudly was the quickest way to agitate any adults close by.

Currys, suppliers of every type of electrical gadget, was the store with choice – from a Regentone at 21 guineas to the Pilot Modernair at 30 guineas ('with a built-in radio plus a four-speed automatic record player for any size of record'). However, the Dansette – from 20 guineas upwards – was seen as the best brand, and by the end of the 1950s its new sensation was a stereophonic set at 45 guineas.

During this decade the old shellac 78-rpm record was on its way out, and a new seven-inch vinyl 45-rpm single was on its way in, along with a new musical rhythm and beat.

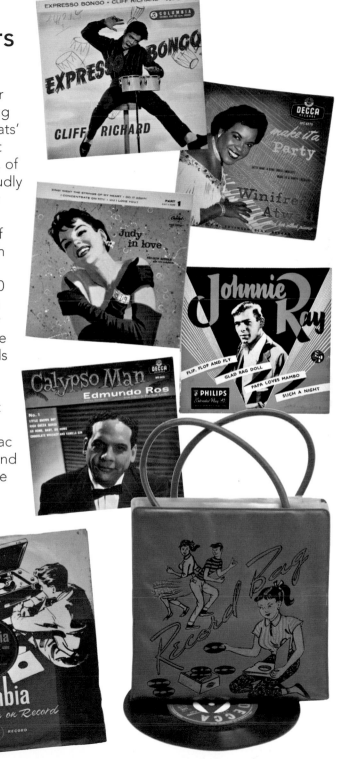

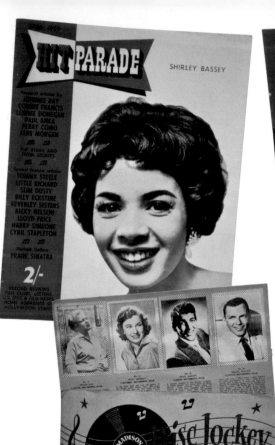

APRIL 1959

HIT PARADE

SHIRLEY BASSEY

Personal articles by
JOHNNIE RAY
CONNIE FRANCIS
LONNIE DONEGAN
PAUL ANKA
PERRY COMO
JANE MORGAN

THE STARS AND
THEIR SECRETS

Special feature articles
TOMMY STEELE
LITTLE RICHARD
SLIM DUSTY
BILLY ECKSTINE
BEVERLEY SISTERS
RICKY NELSON
LLOYD PRICE
HARRY SIMEONE
CYRIL STAPLETON

Portrait Gallery
FRANK SINATRA

2/-

SECOND REVIEWS,
FAN CLUBS, LETTERS,
U.S. DISC & FILM NEWS
HOME ADDRESSES OF
HOLLYWOOD STARS

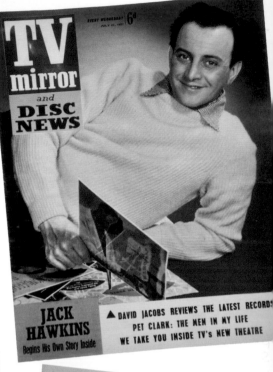

EVERY WEDNESDAY 6d
JULY 27, 1957

TV mirror
and
DISC NEWS

JACK
HAWKINS
Begins His Own Story Inside

▲ DAVID JACOBS REVIEWS THE LATEST RECORDS
PET CLARK: THE MEN IN MY LIFE
WE TAKE YOU INSIDE TV'S NEW THEATRE

MADISON

Disc Jockey
"Star"
Album

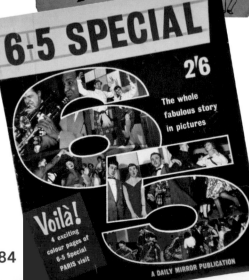

6·5 SPECIAL

2'6

The whole
fabulous story
in pictures

Voilà!

4 exciting
colour pages of
6-5 Special
PARIS visit

A DAILY MIRROR PUBLICATION

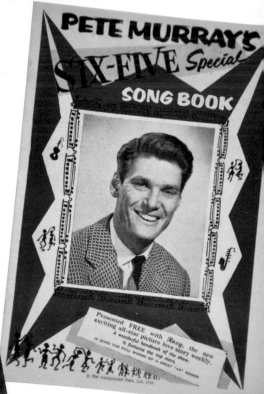

PETE MURRAY'S
SIX-FIVE Special
SONG BOOK

Presented FREE with *Roxy*, the new
exciting all-star picture love story weekly.
A wonderful handbook of the show.
It features the top stars.
IT GIVES THE FULL WORDS OF 15 GREAT "45" SONGS.

© The Amalgamated Press, Ltd. 1958.

Top of the Pops

If you wanted to listen to popular music in the early 1950s, Radio Luxembourg was the station to tune in to. Started in 1933, it moved to the medium wave frequency of 208 metres in 1951.

Sundays belonged to the *Ovaltiney's Concert Party* at 6.15 pm, and later, at 11.00 pm, the *Top Twenty* was hosted by Pete Murray (1950–56). Other eagerly awaited programmes were *Sam Costa's Corner*, *David Jacobs Show* (1957–61), and, from 1958, the *Teen and Twenty Disc Club*. In 1957 producer Jack Good created *Six-Five Special* for BBC television (Saturday evenings at 6.05 pm) presented by Josephine Douglas and Pete Murray.

In 1958 Jack Good moved to ITV to produce *Oh Boy!*, a more energetic pop programme that lasted till May 1959. David Jacobs brought the big hits to *Pick of the Pops* on BBC radio (1956–63) and then *Juke Box Jury* to television (1959–67). On the cover of *208* is Marion Ryan, and on *Hit Parade* is Shirley Bassey. Each record label would release a poster of its top-selling tunes, which record shops would pin up for all to see: His Master's Voice, Decca, EMI.

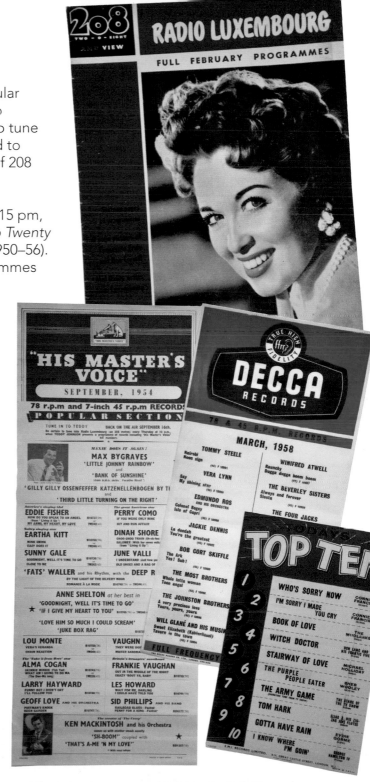

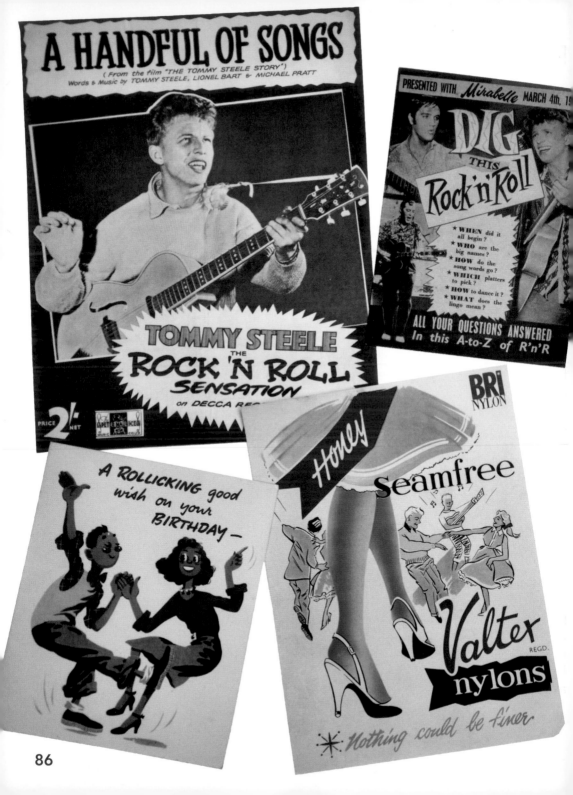

Rock 'n' Roll

Joe Hill Lewis, Willie Johnson, Tennessee Ernie Ford, Bo Diddley, Guitar Slim, Chuck Berry, Fats Domino, Jerry Lee Lewis, Little Richard, Gene Vincent, Louis Jordan – mix this list together with the heritage of dance and sound – jazz, rhythm-and-blues, hill-billy, boogie, jitterbug, be-bop, skiffle ... and rock 'n' roll emerged. Then, in 1957, Bill Haley was let loose with his Comets, arriving from America to tour Britain. The fuse was lit, and now Britain was rocking – Bill Haley's record 'Rock Around the Clock' sold one-and-a-half million copies. The beat was picked up by The Platters, Freddie Ball, The Teenagers, Buddy Holly and, of course, Elvis 'the Pelvis' Presley. In that year, Tommy Steele became the UK's first teen idol with 'Singing the Blues' reaching number one; his film *Half a Sixpence* was another hit in 1967.

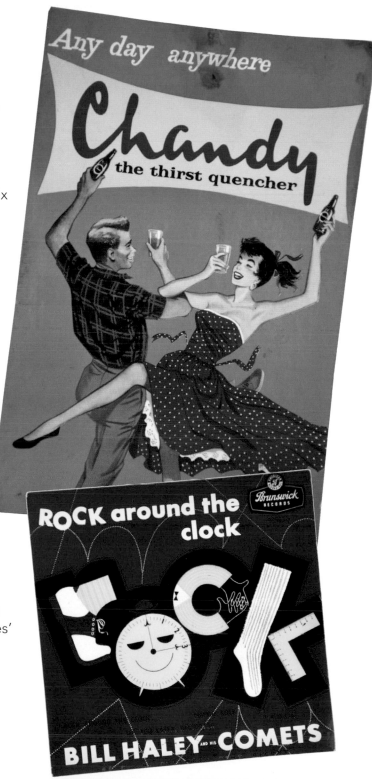

Teenage Romance

'Here they are! Vivid real-life pictures – the thrilling new look in story telling', announced *Mirabelle* for its first issue in 1956. The teenager had been defined back in 1945, and now *Mirabelle* led the way with its romantic-story weekly. The potential of the teenage market was recognized. *Romeo* followed in 1957 with a story called 'Cruise to Romance', which began, 'Falling in love with Steve Simpson was like a wonderful dream. But what was the mystery surrounding him?' In 1958, *Roxy* was launched, and then *Sincerely*, which contained a calograph for easy slimming. Singer Frankie Vaughan was one of many heartthrobs, and he held the spotlight on the first issue of *Boyfriend* in 1959.

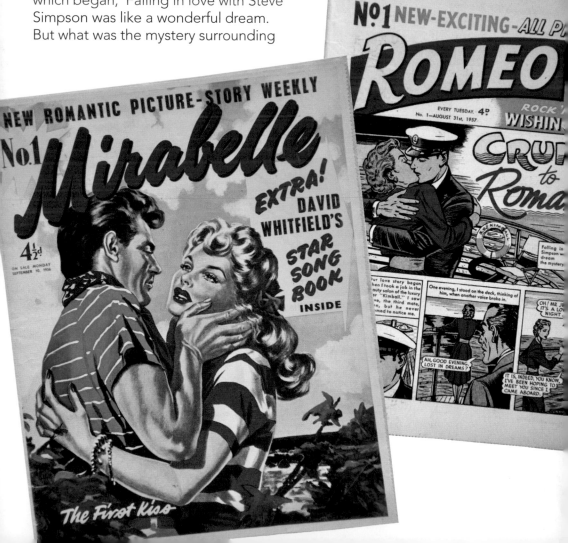

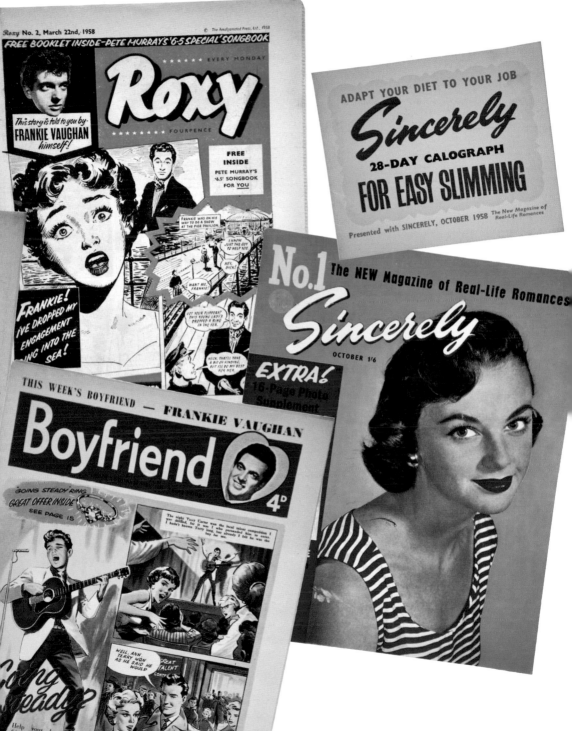

89

Fashion

Little wonder that women wanted to revel in the new fashions. After years of clothes rationing (June 1941 to March 1949), the restraints lifted to reveal an explosion of excessive fabrics and colour. In Paris, Christian Dior had created the 'new look' for the summer of 1947 that emphasized the bust, waist and hips.

Fifties fashion moved from pencil-line suits to flamboyant skirts with layers of petticoats, from pleated polka-dot dresses to floral spun rayon outfits with wide collars. Advances in man-made fibres kept prices down; beyond nylon there were names like Polyester, Crimplene, Terylene, Acrilan and Everglaze. Synthetic material accounted for 20 per cent of sales. Mail order shopping boomed and business tripled during the decade. As 'little adults', the fashion for older children emulated that of their parents – but rebellion was in the air and blue denim jeans were growing in popularity, having arrived from America.

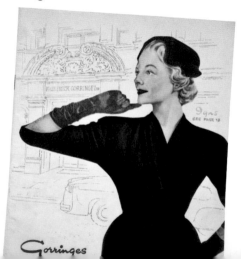

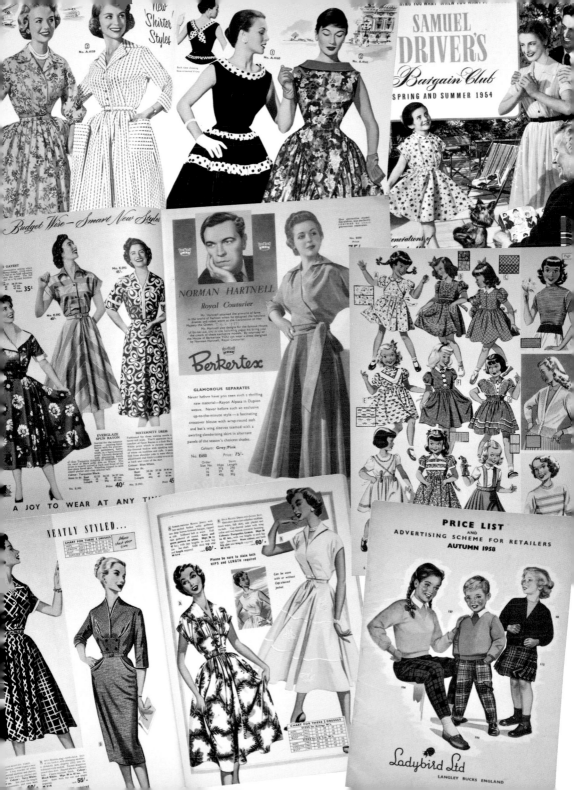

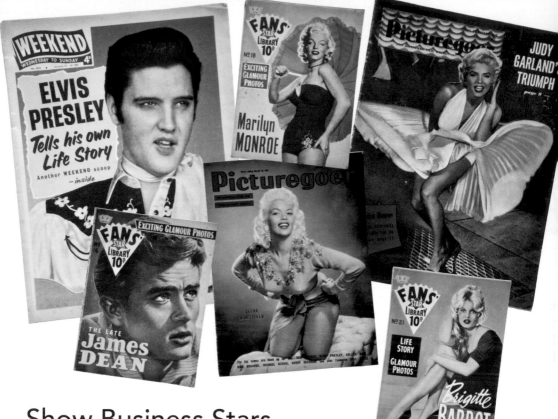

Show Business Stars

Glamour in the 1950s seemed to be imported from America: Hollywood film stars were busting out everywhere. Marilyn Monroe made her name in *Gentlemen Prefer Blondes* (1953), *The Seven Year Itch* (1955) and *Some Like It Hot* (1959) – she died from an overdose in 1962 aged 36. Jayne Mansfield was another sex symbol, starring in *The Girl Can't Help It* (1956) – she died in a car crash aged 34. James Dean played the disillusioned teenager in *Rebel Without a Cause* (1955) and *East of Eden* (also 1955), but died in a car accident aged 24, before the release of *Giant* in 1956.

Elvis Presley, the music icon of the 1950s, was not only commercially successful, but also highly influential. His first US number one was 'Loving You' in 1956 and in the same year 'All Shook Up' was his first number one in the UK. Immediately into the movies with *Love Me Tender*, he featured in four more films in the 1950s, including *Jailhouse Rock* (1957), before being drafted into the US army in 1958. He died of drug misuse in 1977 aged 44. Not everything glamorous came from America; Brigitte Bardot, who was French, became world famous in 1957 with the film *And God Created Woman*.

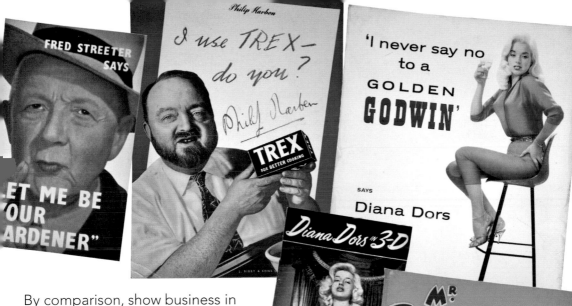

By comparison, show business in Britain may have seemed dull, but there was the blonde bombshell Diana Dors; in 1954, her husband promoted her talent in a semi-nude 3D booklet.

Many personalities found fame through television, and then supplemented their income by endorsing products. Philip Harben was the first TV chef with his cookery programme (1946–51) and Fred Streeter was the nation's radio and television gardener. In 1950, Eamonn Andrews came from Dublin radio to the BBC as a sports commentator. He began hosting the TV game show *What's My Line?* in 1951 and *This Is Your Life* in 1955 (with a five-year break) until his death in 1987.

There were hundreds of other performers who turned their talent to the small screen – one was Richard Hearne, actor, acrobat and dancer who all through the 1950s played Mr Pastry, a lovable, bumbling comic character on children's television.

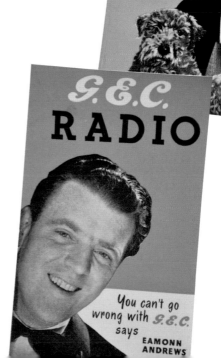

Cinema

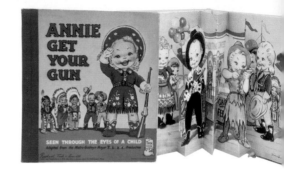

Going out to the cinema was full of fun and fantasy. Musicals were extremely popular; in 1950 *Annie Get Your Gun*, with Betty Hutton and Howard Keel, was a hit, as was *High Society* in 1956 and then in 1958 *South Pacific*, which played for over four years at London's Dominion Theatre – the soundtrack album stayed at number one for 115 weeks. Epics were another feature of the 1950s; Charlton Heston starred in both *The Ten Commandments* (1956) and the biggest budget film of the decade, *Ben-Hur* (1959). Disney released 29 films during the 1950s,

including natural history *The Living Desert* (1953) and *The Vanishing Prairie* (1954), followed by *20,000 Leagues Under the Sea* (also 1954) and *Davy Crockett, King of the Wild Frontier* (1955).

First shown in London in 1954, Cinerama was a deeply curved widescreen with three synchronized 35mm projectors – the audience became part of the experience, as with *South Seas Adventure* (1958).

British film hopes were kept alive by Norman Wisdom (*Trouble in Store*, 1953, to *Follow a Star*, 1959). Then, in 1958, the start of a new series, *Carry On Sergeant*.

A million eager boys and girls attended Saturday-morning film shows. The Odeon and Gaumont cinema clubs had been formed in 1943, followed by ABC and Granada. It cost sixpence to buy a ticket and another sixpence if you wanted a tub of ice cream. A typical programme might include Pathé news, a short cartoon, a B movie and then the feature film. But little could compete against the growing power of television – in 1950 there were 1,400 million cinema admissions, by 1959 only 500 million.

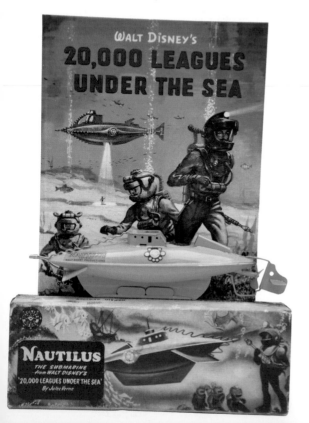

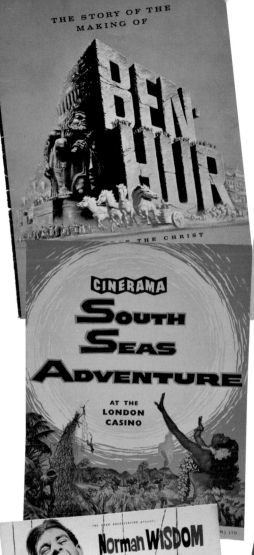

THE STORY OF THE MAKING OF

BEN-HUR

A TALE OF THE CHRIST

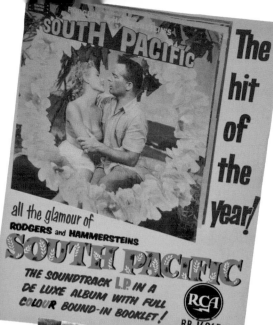

SOUTH PACIFIC

The hit of the year!

all the glamour of **RODGERS** and **HAMMERSTEINS**

SOUTH PACIFIC

THE SOUNDTRACK **L.P.** IN A DE LUXE ALBUM WITH FULL COLOUR BOUND-IN BOOKLET!

RCA

RB 16065

CINERAMA

SOUTH SEAS ADVENTURE

AT THE LONDON CASINO

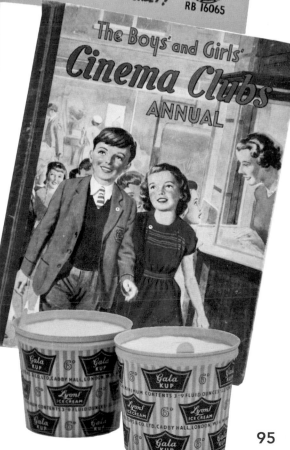

The Boys' and Girls' Cinema Clubs ANNUAL

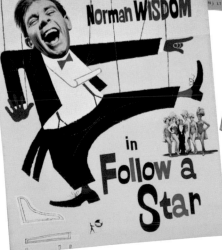

THE RANK ORGANISATION presents

Norman WISDOM

in Follow a Star

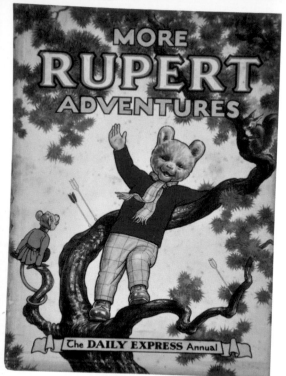

Books for Children

A vast range of books were available for children to read – from the best-selling stories of Enid Blyton's *Famous Five* (21 adventures between 1942 and 1963) and Captain W. E. Johns' *Biggles* tales of a pilot's wartime exploits (96 titles published between 1932 and 1970), to the shunting of *Thomas the Tank Engine* and his friends, written by the Rev. Wilbert Awdry. Another train book from the early 1950s was *Chuff'ty Puff'ty: The Jolly Railway Engine*, which had a resemblance to the engine on the Sugar Puffs cereal box.

Annuals were a popular present at Christmas for boys and girls, and many comic papers and TV series created their own annuals, for instance, *PC49* which ran for 112 episodes between 1947 and 1953. The *Rupert Bear* annual became a classic; the comic strip had begun in the *Daily Express* newspaper in 1920, with the first annual published in 1936 – and they continue to this day.

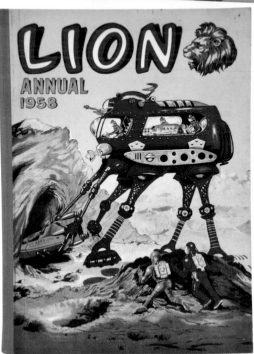

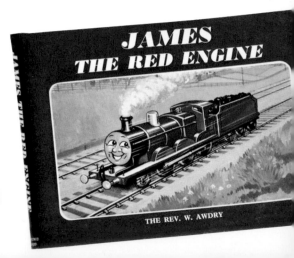

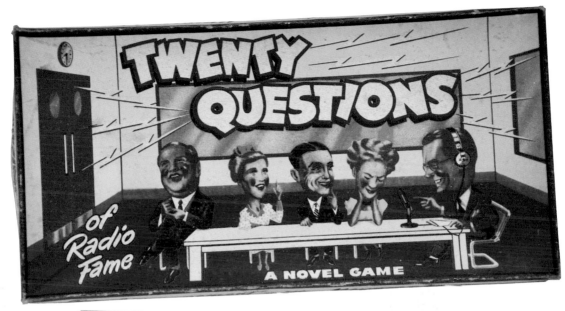

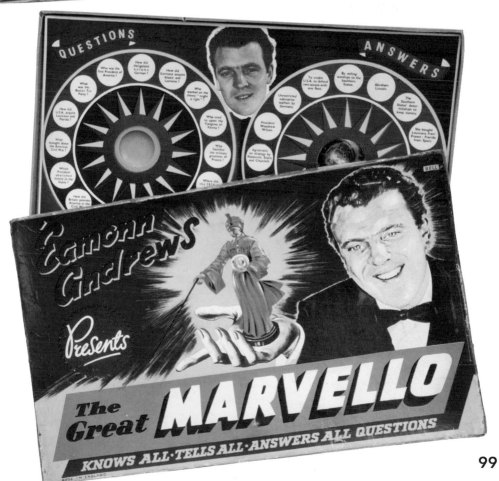

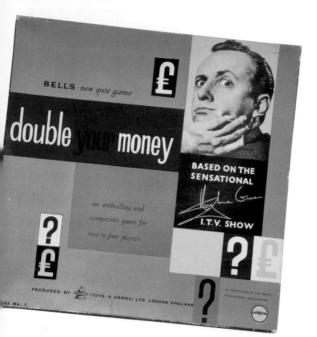

TV Board Games

With the arrival of commercial television in 1955, it was suddenly possible for contestants to win big cash prizes. On Radio Luxembourg there were established game shows – Hughie Green presented *Double Your Money* (sponsored by Lucozade) and Michael Miles invited contestants to *Take Your Pick* (sponsored by Beecham's Pills). Both shows transferred to ITV in 1955, giving away substantial sums – and both continued to 1968. Michael Miles also hosted a similar game show called *Wheel of Fortune*. Already successful in the USA, *The $64,000 Question* came to Britain in 1956, but only lasted two years. The dollars were converted into shillings, thus making the top prize a fabulous £3,200. It was hosted by Jerry Desmonde, an actor mostly known for playing the straight man to Norman Wisdom.

The TV sitcom *Whack-O!* (1956–60) was written by Frank Muir and Dennis Norden and starred Jimmy Edwards, who was best known for his part in the radio programme *Take It From Here* (1948–60); included in the show from 1953 there was a sitcom called *The Glums*, again written by Muir and Norden, where Jimmy Edwards played the role of Pa Glum.

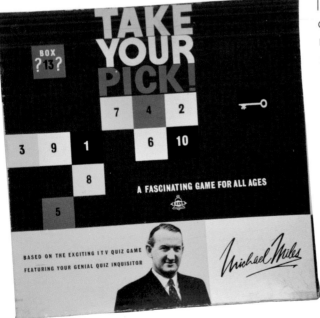

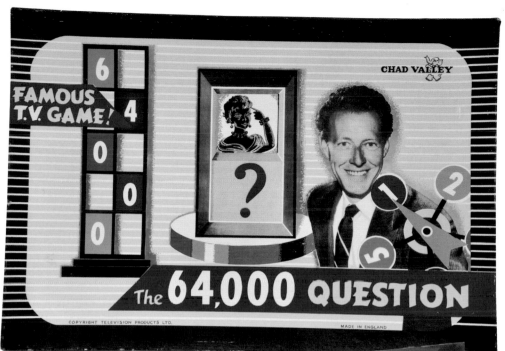

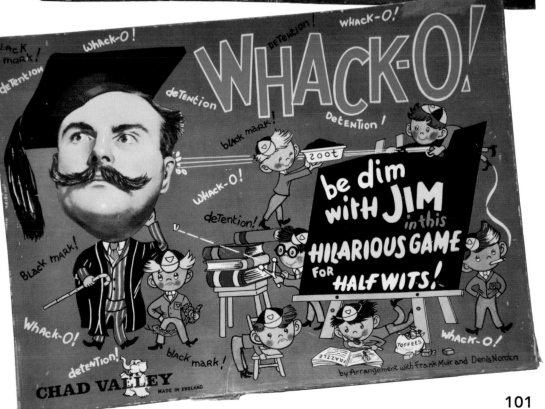

101

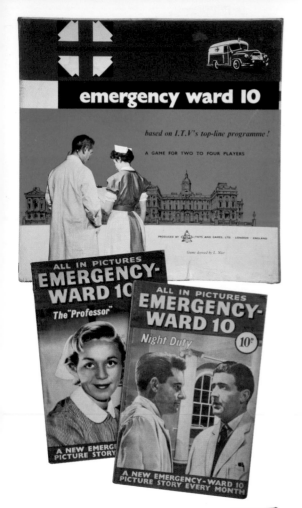

Playing Grown-ups

Having exhausted the role of shooting the baddies and tying up Indians, the next most popular adult job was to be a bus conductor or to run the post office, or least that was what the toy manufacturers thought (those who wanted to be an engine driver could just play with their train set). The bus conductor's outfit included the ticket punch and hat, which gave the wearer more authority to say 'room for one more on top'. Post office play was all about serving customers with stamps and taking down telegram messages from the telephone.

ITV promoted the intrigues of nursing in their twice-weekly soap opera, *Emergency – Ward 10*, set at the fictional hospital Oxbridge General. It ran for 1,016 episodes between 1957 and 1967. BBC's *Dixon of Dock Green* was another popular series. It was shown on Saturday evenings at 6.30 pm, with Jack Warner playing George Dixon, whose opening line was 'Good evening, all'; between 1955 and 1976, there were 432 episodes. Who knows how many future policemen were inspired by Dixon's cool handling of the criminals.

So many toys could transport a child into his or her own world of make believe – perhaps running a milk bar with teenagers gathering at this new meeting place to play the latest hit on the jukebox.

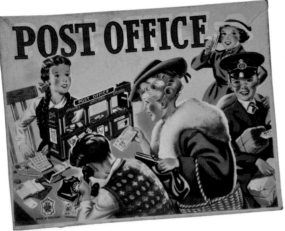

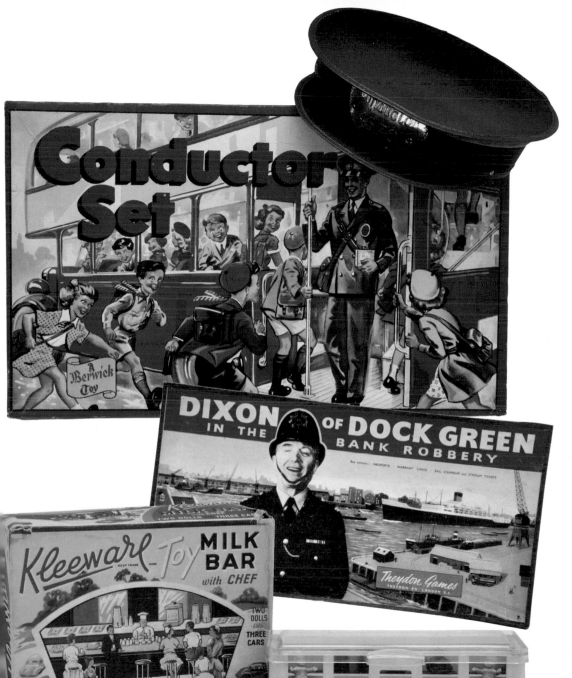

Cowboys

Behind the living room sofa or the garden hedge lurked a cowboy ready to defend his territory. Equipped with a gun, and with a holster tied to his belt, boys (and sometimes girls, playing the Indians) revelled in fighting the outlaws and rustlers.

Youngsters' imaginations had been fired up by an epidemic of American Western films, which had now extended on to TV screens. John Ford's 1950 movie *Wagon Master* morphed into a TV series called *Wagon Train* in 1957, the year that *Hawkeye*, a more realistic TV series was shown. *The Lone Ranger*, with his horse Silver (1949–57) was another popular show, while *Roy Rogers* (1951–57) riding Trigger became known as the 'king of the cowboys'. Davy Crockett was king of the wild frontier in a Disney film released in 1955.

At the end of the decade, Clint Eastwood appeared in *Rawhide* (1959–65), setting him on the path to spaghetti Westerns. Other favourite cowboys included Hopalong Cassidy, Gene Autry, Kit Carson, Billy the Kid, Cisco Kid and Wyatt Earp.

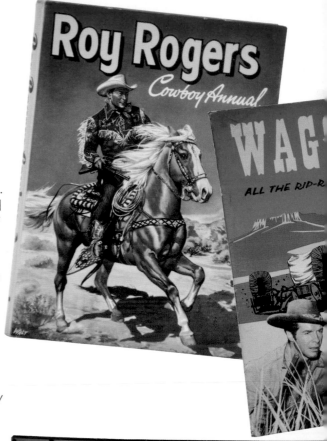

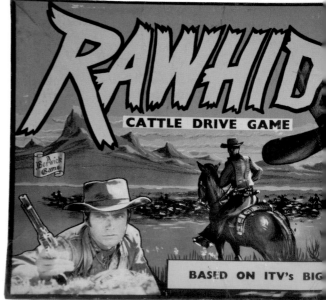

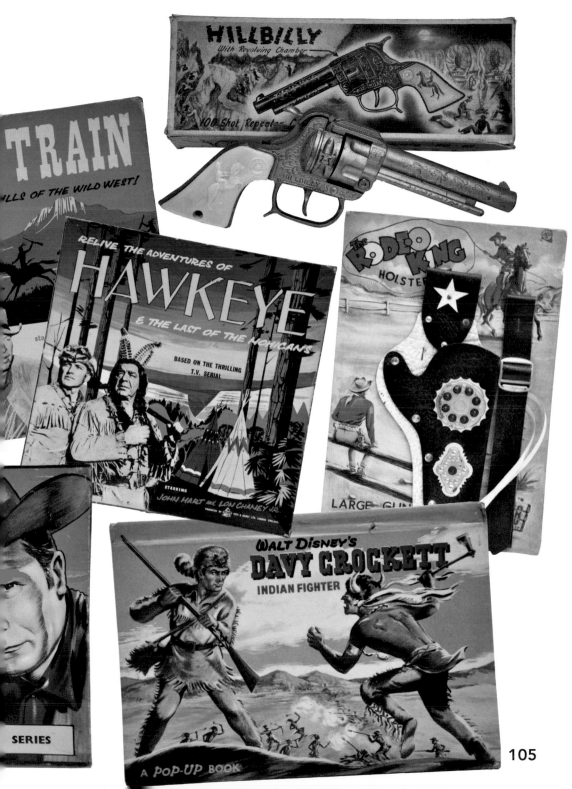

HILLBILLY
With Revolving Chamber
100 Shot Repeater

TRAIN
HILLS OF THE WILD WEST!

RELIVE THE ADVENTURES OF
HAWKEYE
& THE LAST OF THE MOHICANS
BASED ON THE THRILLING
T.V. SERIAL
STARRING
JOHN HART and LON CHANEY JR.

The RODEO KING
HOLSTER
LARGE GUN

WALT DISNEY'S
DAVY CROCKETT
INDIAN FIGHTER
A POP-UP BOOK

SERIES

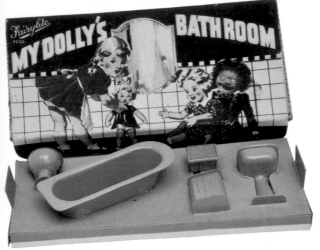

Dolls

The constant companion for generations of girls has been a doll, and now in the 1950s dolls were becoming more realistic as new plastics made flesh look and feel more lifelike. By the end of the decade, malleable plastic allowed the hair to be rooted.

Baby dolls needed Mum or Gran to knit some garments, while larger and more expensive dolls came ready-clothed. In the case of Pedigree's Pin-Up doll, 'it has an expensive nylon wig which you can shampoo and play-wave'. Plenty of accessories were available, even a complete bathroom suite ... in pink. The hula-hoop craze was a global phenomenon in 1958, reflected in a mechanical spin-a-hoop toy.

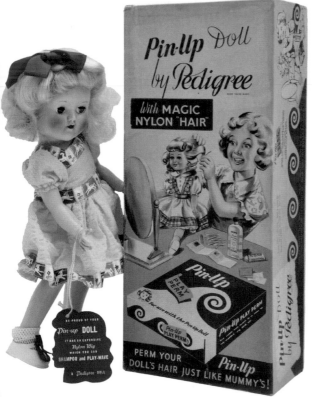

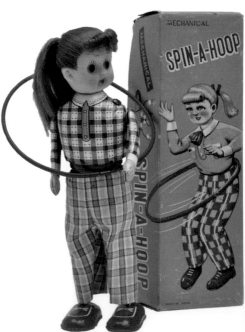

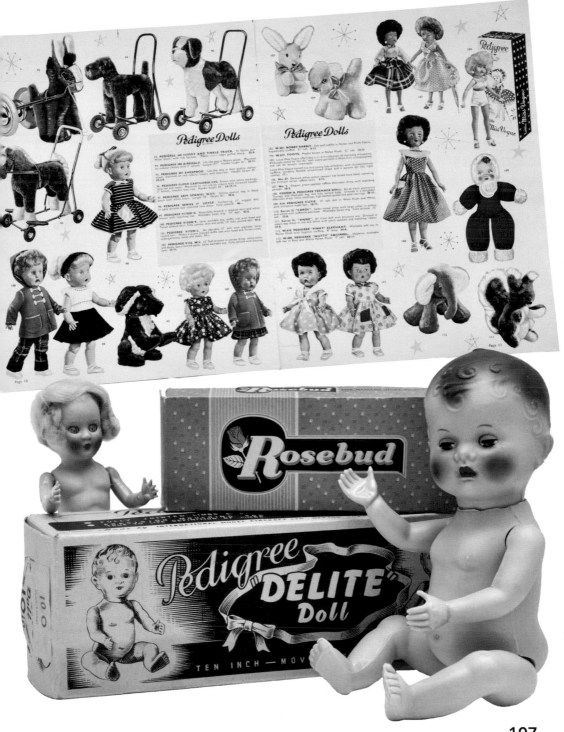

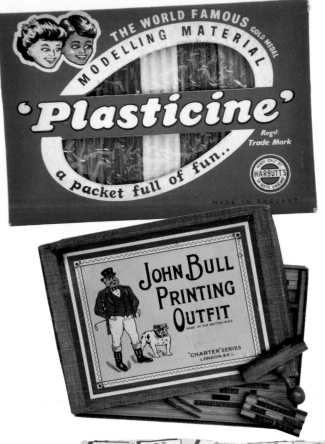

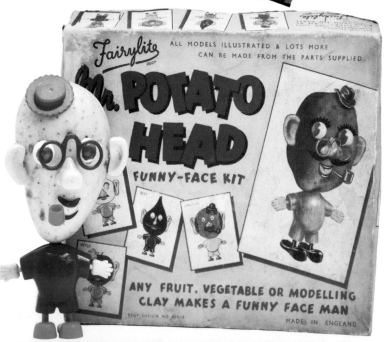

Being Creative

There is something so satisfying about being able to say, 'I made that all on my own', and it doesn't really matter whether it is painting by numbers, stencilling with crayons or the more advanced plaster model casting. Plasticine had been devised by William Harbutt in 1897 for his art students – a few years later he was making it for children. Ever since, the 'packet full of fun' has become part of many childhoods; over time the individual colours inevitably merged into a muddy brown.

Mr Potato Head was an ingenious innovation that arrived from America in the early 1950s, and provided an hour or so of funny faces with any fruit or vegetable lurking in the kitchen. For some, the John Bull printing outfit started with stamping your name on all your possessions, then, with careful application aided by the tweezers, the fiddly task brought satisfaction when a complete sentence emerged, perhaps to start a career in the printing industry.

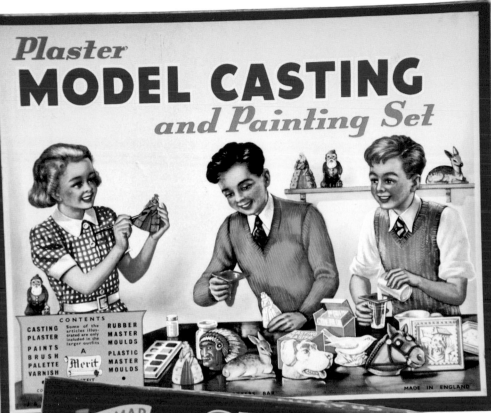

Plaster
MODEL CASTING
and Painting Set

CONTENTS		
CASTING PLASTER	Some of the articles illustrated are only included in the larger outfits	RUBBER MASTER MOULDS
PAINTS BRUSH PALETTE VARNISH	A *Merit* OUTFIT	PLASTIC MASTER MOULDS

MADE IN ENGLAND

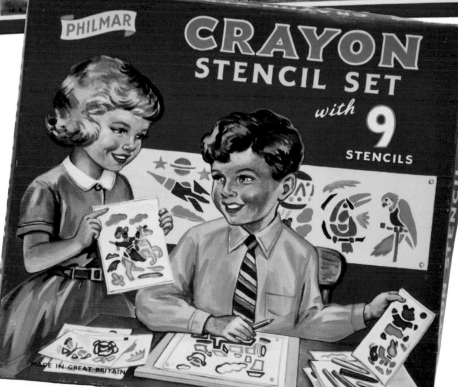

PHILMAR CRAYON STENCIL SET
with 9 STENCILS

MADE IN GREAT BRITAIN

109

Model Building

There is an art to sticking little bits of plastic together, and the patience and perseverance required provides the satisfaction of making a model aircraft, with all its insignia – thanks to sticky vinyl decals. Just before the outbreak of WWII, Nicholas Kove, a Hungarian living in Britain, was making inflatable rubber toys. He called his company Airfix.

In 1947 Airfix bought an injection moulding machine to make plastic combs. Then, in 1949, Ferguson's ordered a quantity of plastic model tractors for its sales reps to give away. Subsequently, Airfix also sold some in kit form to Woolworths. Encouraged by Woolworths' interest, in 1952 the first of many bagged kits were produced – the *Golden Hind*. The first kit aircraft was a Spitfire, released a year later. Most of the competition came from the USA, such as Revell, whose invasion began in 1956.

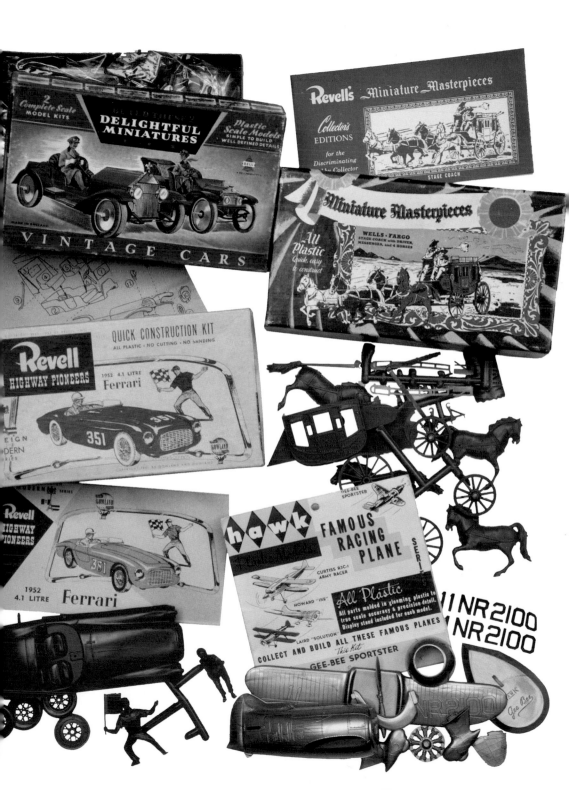

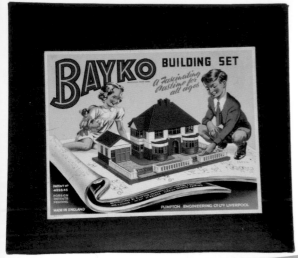

Construction Toys

'Meccano enables boys to build realistic models of motor cars with gear-boxes and differentials. Meccano caters for that urge to construct and experiment, which exists in all boys.' It seemed that anything was possible with a spanner and a screwdriver – helicopter, military tank, giant crane, merry-go-round. 'Meccano model-building is the most fascinating of all hobbies, because it never becomes dull.' Originally called Mechanics Made Easy in 1901, Frank Hornby sought a shorter name for his invention. Meccano Ltd was set up in 1907. With justification, by the 1950s, it called Meccano 'the toy of the century'.

Wooden building bricks were the bedrock of construction toys, but in the 1930s came Bayko (1934–67) with bricks made from Bakelite, 'the fascinating never failing diversion for boys and girls'. Then came Minibrix (1935–76), 'the complete building system in miniature', the bricks being made from rubber. Airfix joined the house-building spree in the 1950s; Lego arrived in 1960.

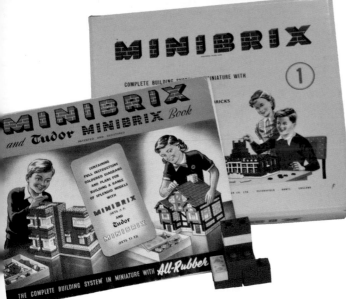

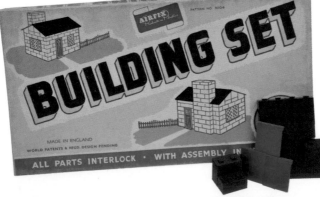

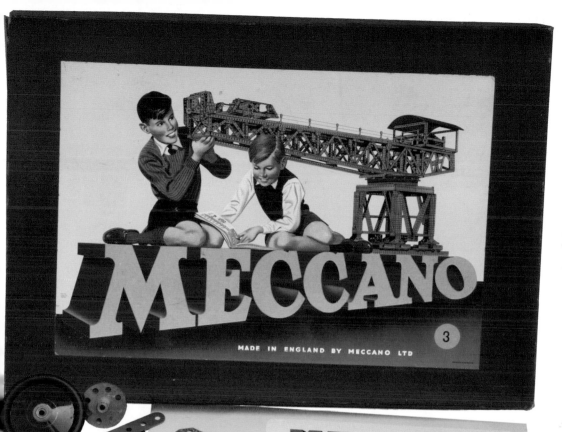

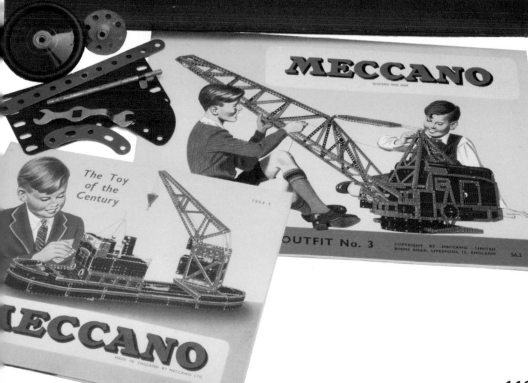

Puppets

Most of the early children's TV characters were string puppets, and that included Francis Coudrill's Hank the Cowboy with his horse Silver King, and Mr Turnip, who appeared with actor and comedian Humphrey Lestocq. Both puppets appeared on *Whirligig* (1950–56), a fortnightly treat on Saturday afternoons. But the first puppet on TV after the war was Muffin the Mule in 1946, accompanied by Annette Mills. Created by Czech immigrants Jan and Vlasta Dalibor, Pinky and Perky appeared on BBC TV between 1957 and 1968.

All this puppetry was fortunate for Bob Pelham. He had started his company, Wonky Toys, in 1947, making wooden toys held together with string. This led to puppets and Pelham Puppets was born in 1948. All children wanted to do now was to animate their TV heroes.

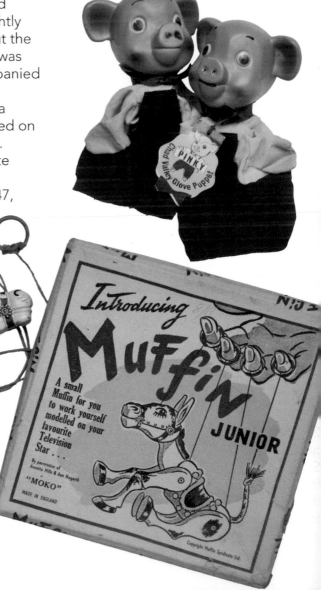

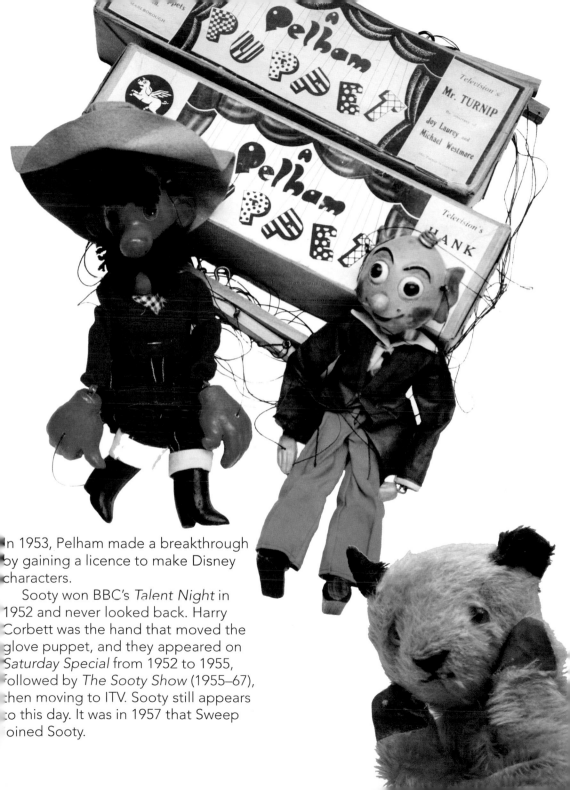

In 1953, Pelham made a breakthrough by gaining a licence to make Disney characters.

Sooty won BBC's *Talent Night* in 1952 and never looked back. Harry Corbett was the hand that moved the glove puppet, and they appeared on *Saturday Special* from 1952 to 1955, followed by *The Sooty Show* (1955–67), then moving to ITV. Sooty still appears to this day. It was in 1957 that Sweep joined Sooty.

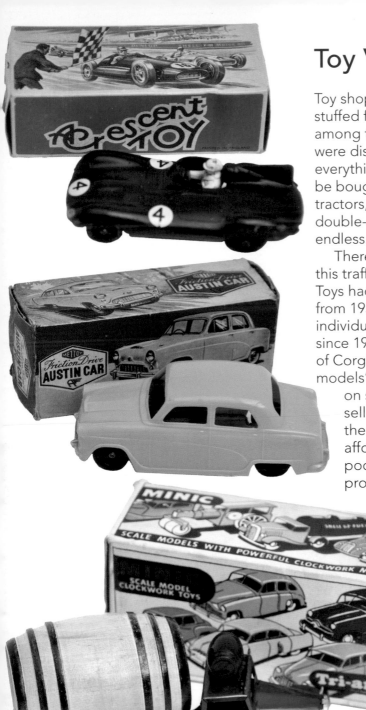

Toy Vehicles

Toy shops in the 1950s were stuffed full of temptation, and among the dolls and teddy bears were displays of model vehicles – everything that was on the road could be bought in miniature: saloon cars, tractors, steam rollers, pick-up trucks, double-decker buses, the choice was endless.

There were many firms creating this traffic jam of excitement. Dinky Toys had been made since 1934, and from 1952 each toy was sold in its own individual box. Mettoy, a toy company since 1933, launched its range of Corgi 'precision die-cast scale models' in 1956. Matchbox Toys went on sale in 1954, following success selling Coronation coaches the previous year. Priced at an affordable 1/6d, the average pocket money for a week, they proved to be hugely popular.

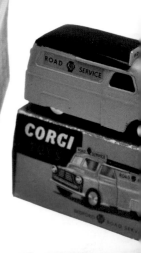

DINKY TOYS

157
Jaguar XK 120 Coupé
2/9

651
Centurion Tank
7/11

430
Breakdown Lorry,
Commer chassis
5/6

400
B.E.V. Electric Truck
2/11

343
Farm Produce Wagon
3/6

154
Hillman Minx Saloon
2/6

290
Double Deck Bus
4/-

SHELL CHEMICALS LIMITED

DUNLOP

OVALTINE

DINKY SERVICE

DINKY TOYS

DINKY TOYS 340

LAND ROVER

MATCHBOX SERIES
A: MOKO LESNEY

"MATCHBOX" SERIES 1959 EDITION

MATCHBOX SERIES No. 44
A MOKO LESNEY
MADE IN ENGLAND

ILLUSTRATED RANGE OF MODELS

A MOKO LESNEY
PRODUCT
Printed in England

EVENING NEWS

CORGI TOYS
PRECISION DIE-CAST SCALE MODELS

MOTOR CARS

Space Toys

'There are many ways of making a traitor's tongue wag! Already you have proved life means more to you than Earth's ridiculous code of honour.' So said the Mekon, Dan Dare's nemesis in the space adventure on the cover of the *Eagle*.

Once the paper ration had been relaxed in 1950, *Eagle* took off. 'Dan Dare, Pilot of the Future', was illustrated by the accomplished Frank Hampson, who also wrote the first stories. But the inspiration had come from an Anglican vicar, Marcus Morris, who thought that older boys should have something more. Other stories in the *Eagle* included PC49 and Riders of the Range.

Dan Dare fuelled interest in science fiction, and inspired a vast range of space toys. During the decade, these imaginative stories and models began to close the gap between fiction and reality, as real space rockets and sputniks were launched.

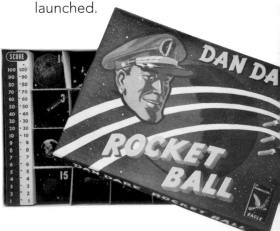

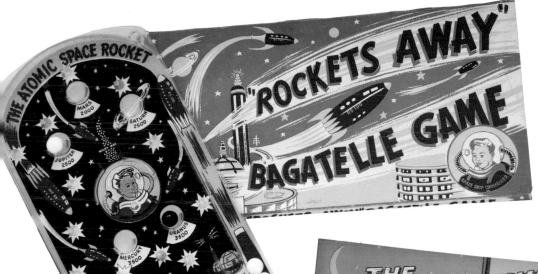

THE ATOMIC SPACE ROCKET

MARS 2000
SATURN 2500
JUPITER 2500
URANUS 3500
MERCURY 3500
THE MOON 5000
SPACE STATION No.1 1000
SPACE STATION No.2 2000

CRASH LANDING SHIPS LOST 0 — SUCCESSFUL TRIAL 500 — SAFE LANDING TRY AGAIN

O THE EARTH

"ROCKETS AWAY" BAGATELLE GAME

SPACE SHIP COMMANDER

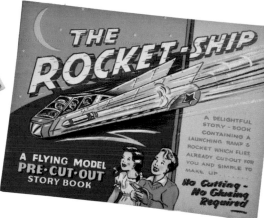

THE ROCKET-SHIP

A FLYING MODEL PRE·CUT·OUT STORY BOOK

A DELIGHTFUL STORY·BOOK CONTAINING A LAUNCHING RAMP & ROCKET WHICH FLIES ALREADY CUT·OUT FOR YOU AND SIMPLE TO MAKE UP

No Cutting – No Glueing Required

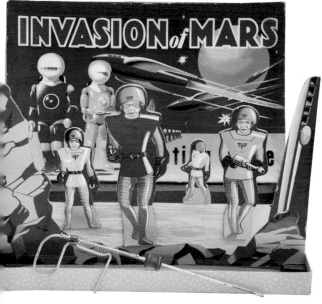

INVASION of MARS

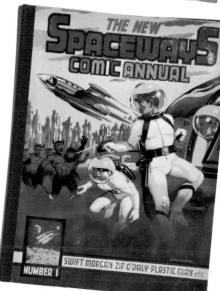

THE NEW SPACEWAYS COMIC ANNUAL

NUMBER 1

SWIFT MORGAN · ZIP O'DALY · PLASTIC MAN etc.

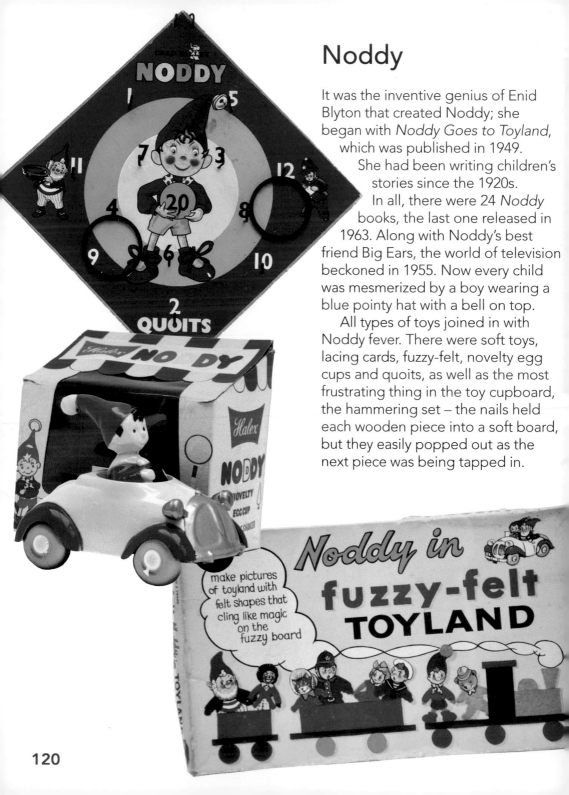

Noddy

It was the inventive genius of Enid Blyton that created Noddy; she began with *Noddy Goes to Toyland*, which was published in 1949.

She had been writing children's stories since the 1920s.

In all, there were 24 *Noddy* books, the last one released in 1963. Along with Noddy's best friend Big Ears, the world of television beckoned in 1955. Now every child was mesmerized by a boy wearing a blue pointy hat with a bell on top.

All types of toys joined in with Noddy fever. There were soft toys, lacing cards, fuzzy-felt, novelty egg cups and quoits, as well as the most frustrating thing in the toy cupboard, the hammering set – the nails held each wooden piece into a soft board, but they easily popped out as the next piece was being tapped in.

make pictures of toyland with felt shapes that cling like magic on the fuzzy board

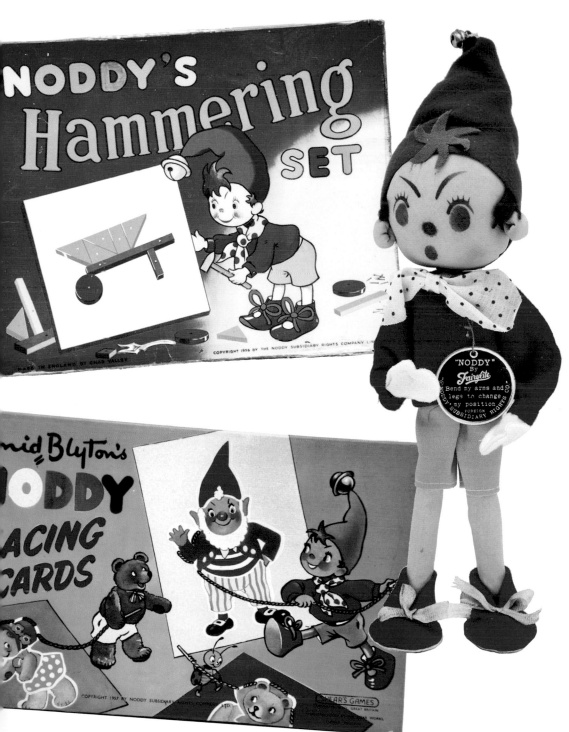

Children's TV Characters

Once television was back on air in June 1946, children's characters sprang up to perform and entertain. An early entry in October 1946 was *Muffin the Mule*, accompanied by Annette Mills, often on the piano with Muffin dancing on top. Sadly, Annette Mills (sister of actor John Mills) died in 1955. The series transferred to ITV for 1956 and 1957. On the cover of her gift book are many of Muffin's friends, such as Peregrine the Penguin and Prudence Kitten.

Muffin's popularity ensured a wide range of merchandise, including Pin the Tail on Muffin, a Louise the Lamb and Muffin rug and a pouffet (that cost 40/-) to sit on while watching TV.

Among the characters leaping out of the *TV Comic* annual are Bengo the Boxer puppy, Coco the Clown, Packi the Elephant, Bom the Drummer and Lenny the Lion, first seen on TV in 1956 – Terry Hall was the ventriloquist, with the catchphrase 'Aw, don't embawass me!'

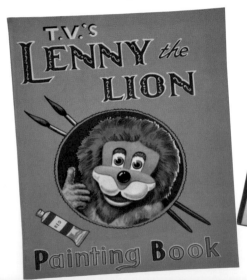

's see you pin
tail on me
t where tails
re meant to be!

MADE IN ENGLAND

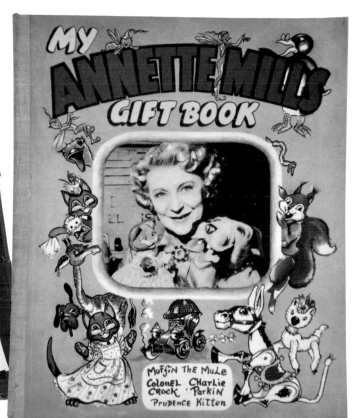

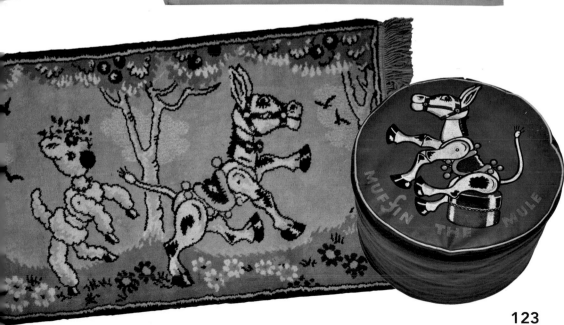

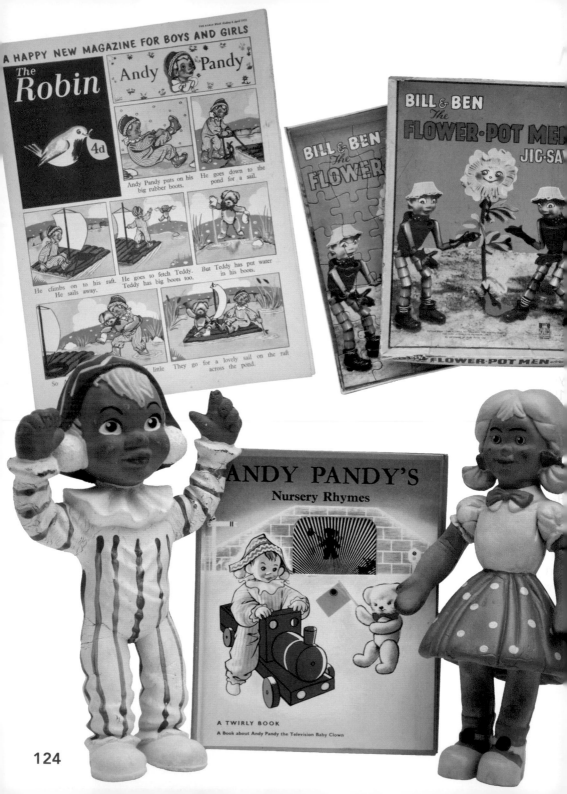

124

Watch with Mother

For those not yet at school, the BBC created a TV programme in 1950 called *For the Children*. In that year, Andy Pandy became a regular favourite, soon joined by his friends Teddy and Looby Loo. The 15-minute puppet shows were transmitted live, but it was soon realized that it would be better to pre-record them, and 26 episodes were made on 16mm film and transmitted from 1952, continuously repeated until 1970.

Watch with Mother took over in 1953 (lasting for another 20 years) broadcasting on weekdays. *Andy Pandy* was shown on Tuesdays – if you wanted a further dose, from 1953, *Andy Pandy* appeared on the cover of *Robin* each Monday. The Wednesday slot was taken by the 'flobbadob'-speaking *Bill & Ben the Flowerpot Men* (first seen in 1952), also starring the flower Little Weed. *Rag, Tag and Bobtail* appeared on Thursdays (from 1953), and on Fridays from 1955 *The Woodentops* family strutted their stuff. On the cover of the *Children's Hour* book of 1955 can be seen: (left to right) Billy Bean, Sooty with Harry Corbett, a Bumbly, magician David Nixon, Fuzz, Mr Pastry and Yoo-Hoo.

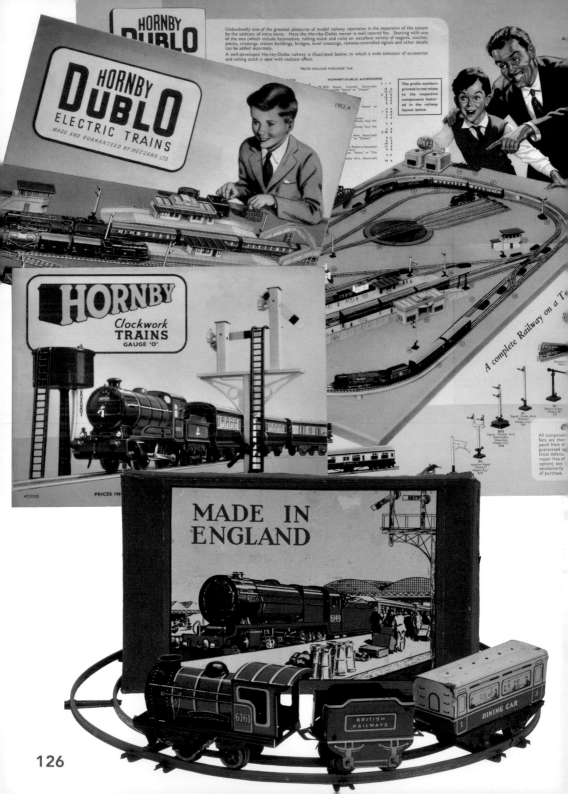

Toy Trains and Planes

'Young boys find endless delight and satisfaction in all that a Hornby Clockwork railway has to offer.' But however much excitement there was in winding up your locomotive, electric trains had greater realism. So, after twenty years of winding, Hornby produced its Dublo electric train in 1936. More affordable in the 1950s, now Dad (and just count how many fingers he has) was excited to be involved with 'a complete railway on a table'. Plenty of clockwork train sets were still available, like the basic 'Made in England' outfit with British Railways insignia.

Flying a toy plane could easily be achieved with an outstretched arm and appropriate noise – painting the sleek lines of Comet 1 could also be a thrill. De Havilland's Comet went into service in 1952, the first jet-propelled airliner, but a series of accidents led to modifications, with Comet 4 taking off in 1958. Plastic meant toys were so much cheaper. The Vickers Viscount was a medium-range turboprop airliner, replacing the conventional piston engine. BEA flew the Viscount in 1953, being the world's first turboprop airline service.

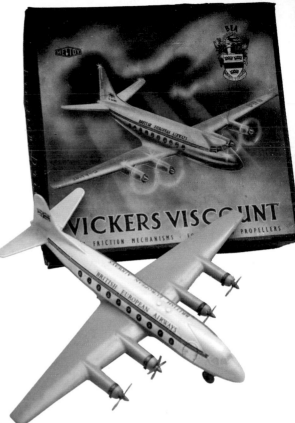

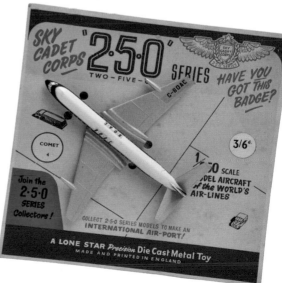